Advance praise

"Lois Stark's committed intelligence brings pictures and stories to life and enables people to see and interpret the world with an enlightened perspective that is increasingly rare in this fragmented and scattered society. Watching her 'connect the dots' is a great learning experience. Stark brings words and pictures full of common sense but confronting the most complex challenges. She presents ideas of extraordinary value to artists, businessmen, and scientists."

—Barry Munitz, former president and CEO, The J. Paul Getty Trust

"Lois Stark is an imaginative thinker—an insightful artist who takes the particular and makes it universal. She is an inspiring guide who discerns patterns and tells a compelling human story."

—Edward Hirsch, poet, president, John Simon Guggenheim Memorial Foundation

"Stark allows images to form their own story. This book will be a lot of fun. It will start conversations. It will delight both the eye and the mind."

—John H. Lienhard, commentator, National Public Radio; author, *Engines of Our Ingenuity* and *Inventing Modern*

"One of the ways to imagine the potential and scope of this project is to think of Lois Stark as a 'Female Joseph Campbell.' A book of great depth and originality."

—Eli N. Evans, president emeritus, Charles H. Revson Foundation; steward and funder of PBS Projects

"Lois Stark has the skill to find order in the vast chaos of our collective history. This book is like donning an old pair of glasses to better see history unfolding before our eyes. It shows us the seeds of change now taking hold and critical clues marking civilization's next step forward."

—George Kaufman, former vice-chairman, Omega Institute

THE
TELLING
IMAGE

SHAPES OF
CHANGING TIMES

LOIS FARFEL STARK

Image Editors KELLY ULCAK MOSS,
HOLLY WALRATH

THE
TELLING
IMAGE

SHAPES OF

CHANGING TIMES

GREENLEAF
BOOK GROUP PRESS

Published by Greenleaf Book Group
Austin, TX
www.greenleafbookgroup.com

Distributed by Greenleaf Book Group

Design and composition by Greenleaf Book Group
Cover design by Greenleaf Book Group

Image credits appear on page 177, which serves
as an extension of the copyright page.

Cataloging-in-Publication data is available.

Print ISBN: 978-1-62634-471-6

eBook ISBN: 978-1-62634-472-3

Printed in China on acid-free paper

17 18 19 20 21 22 10 9 8 7 6 5 4 3 2 1

First Edition

Dedicated to my beloved family

My husband, George Stark

Our sons, Ben D. Stark

Daniel J. Stark

My parents, Esther and Aaron Farfel

Contents

Part I | # POINT OF VIEW

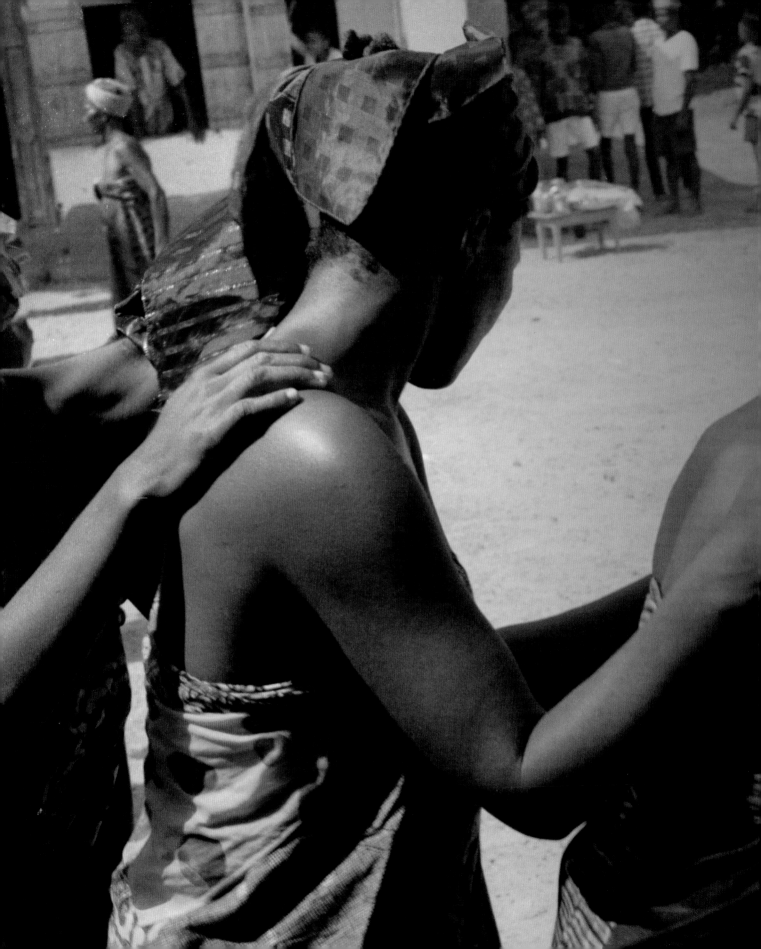

We do not just live in the world, we live in a picture or version of it, of how it hangs together, of what it means.

—*King's College Chapel Exhibit*

Connecting the Dots

How We Describe the World Inscribes Our Thinking

How do we humans make sense of the world? As a documentary filmmaker for NBC News, I was trained to look for the telling image—a picture that gives the essence of the story. In covering countries in times of tension and transition, I had to look through other people's eyes to learn how they saw the world. I filmed in Abu Dhabi before the United Arab Emirates were unified, in Cuba ten years after their revolution, in Northern Ireland when their religious conflict burst into urban warfare, and in Liberia covering its social split. While history gives us versions of a story, a telling image has the power to tap a deeper understanding.

I practiced seeing with new eyes, open to take in the unfamiliar and to discover clues to another culture's worldview. Dropping into a foreign country and trying to understand it enough to present its various factions, historic background, and current controversy was daunting and humbling. I knew I needed to lasso the topics at play, and I knew I would never know everything. One approach I took was to step back and look at the situation with the largest lens, seeing all sides, noticing the geography that influenced the culture's way of living, and learning the historic background. I had to find an image that could relay the issues and emotions,

the culture and landscape, in a way that could convey more than words can explain.

Searching for the telling image of a story, I found one, hiding in plain sight. It was shape itself. Once I looked for shape, I saw it everywhere—in shelters, social systems, and sacred sites. From indigenous cultures to modern societies, our answers to survival, social bonding, and sacred symbols differ vastly. Yet the blueprint for each culture became clear when I looked for shape.

In every era, humans search for pattern and meaning. I became interested in a culture's lens, their picture and version of "how it hangs together, of what it means." As an observer, a witness to the wild variety and eras of human development, I realized how something as simple as shape could help us see the essence of our past, giving us clues to where we are headed and how we make sense of the world.

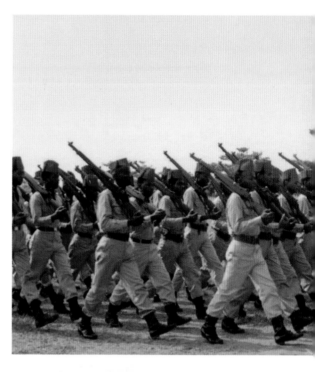

Liberia 1970

Round thatched huts formed a circle in a forest settlement where I filmed young girls celebrating the completion of their initiation rituals, while making a documentary for NBC News. For weeks, the girls were sequestered in the woods learning the timeless skills of childbirth, and how to find medicinal herbs and edible plants. The day of the celebration, a masked shaman, clothed in grass and straw, led the girls onto the packed dirt of the compound's central hub. With white cloth wrapped round and round their hips, their swaying steps traced circular movements. As I watched their bare feet rotate in a circle dance, my head bobbed with their rhythm, and my feet shifted weight to the sound of the drumming. I felt enveloped by their round settlement, the circle of their dance, and the life cycle of their rituals.

The next day I filmed a military parade in Monrovia,

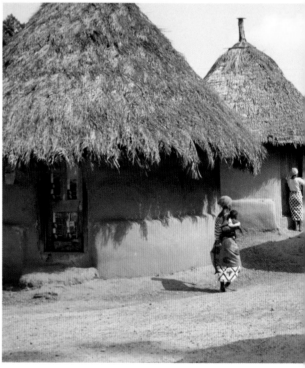

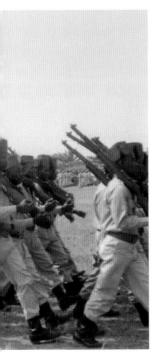
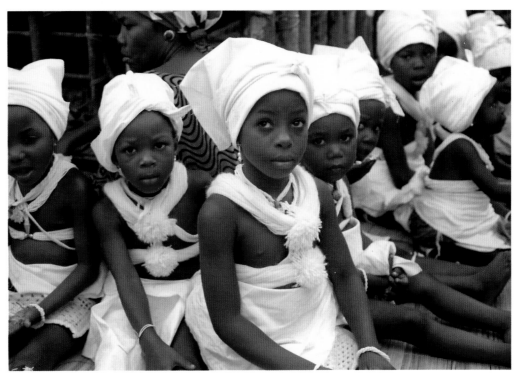

Top: President Tubman and his troops, Liberia
Bottom: Liberia forest settlement and Initiation ceremony

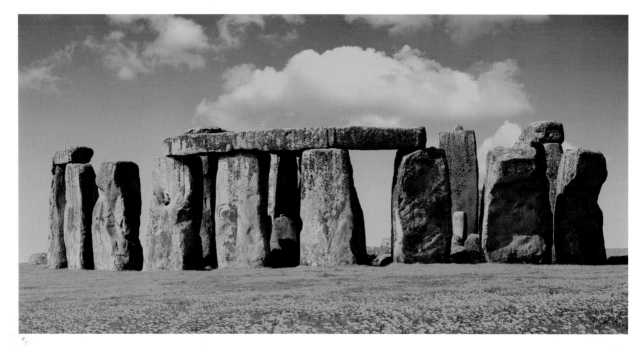

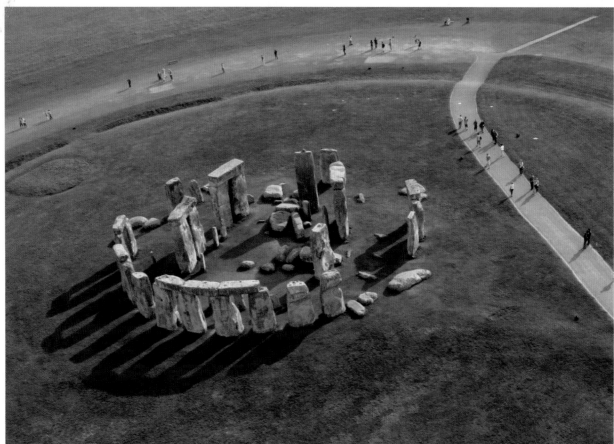

Liberia's capital. Soldiers lined up shoulder-to-shoulder, row upon row, in perfect pods in front of their generals, who stood in a straight line as they reviewed the troops. Then, the soldiers marched into the streets of Monrovia, a city laid out as a grid.

By the 1970s, most of Liberia's bush settlements had traded in their round huts and cyclical rituals for the grid of city streets and soldier line-ups. A culture embedded in nature, a social group woven in common identity, a spiritual idea embodied by masked shamans covered in grass had transformed into a way of living delineated by the square blocks of a town, where streets and soldiers organized in lines and squares, instead of curves and circles.

When I arrived back in the States after my assignment, I couldn't shake the images of shapes out of my head: How two very different communities expressed themselves and their surroundings through such opposite shapes seemed meaningful. It made me see my own home, desk, block, downtown with fresh eyes. What might the very circles of a dance and hut versus the right angles of my books, buildings, and city streets tell me about my mental map?

England 1996

The question of shape continued to haunt me. Years later, as a tourist, I explored Stonehenge with the same curiosity and excitement that I had when I danced in a circle with the women in Liberia. I was still trying to figure out how different cultures saw themselves in the world.

Wind in my face, sun in my eyes, I stood at the center point of Stonehenge, enveloped by concentric circles. Beside me stood an inner ring of stone pillars, wrapped by another ring of monolithic stones. Two more circles—a round ditch and an earthen mound—surrounded the inner stone rings. It felt as if I were in the bull's-eye of a target, at the center of a grand idea still speaking to me after three thousand years.

The people who built Stonehenge understood their world as organized by nature. The stone layout reflected a template of nature's cycles, aligning humans to the recurring rhythm of life. The exact placement of the pillars indicated season change at the midwinter and midsummer solstice. From above, the layout looked like a web: rings, cycles, and connections. It reminded me of being in the hub of the forest settlement in Liberia decades ago.

Stonehenge,
Wiltshire, England,
2500 BC

The next day I visited King's College Chapel, in Cambridge, England. As I walked down the nave toward the altar, steep arches and high columns urged my eyes upward. The vaulted ceiling ribs, steeples, and spires gracefully stretched toward a heaven beyond reach like fingertips pressed together in prayer, pointing toward the divine above. Through their use of vertical columns and spires, the builders wordlessly expressed their view of a world as a vertical ladder with the payoff at the top. Theirs was a time of hierarchy—the world was controlled by a king and created by a god above, whose word came to the masses through the priest. The chapel inspires and intimidates. Its beauty still stuns.

The ancient humans dancing in circles under the moon praying for healing or harvest at Stonehenge must have felt embedded in Earth's cyclical, seasonal nature—at one with the circling whole. Similarly, the devotees praying for favor from a duke in King's College Chapel would not have imagined an alternative to the vertical order that penetrated every aspect of their lives. I began to realize that shape, in stone circles or church steeples, could reveal the mindset of an era, how humans viewed their world and understood their place within it.

I was hooked, on a trail, curious to understand where today's version of order came from and where it was going. What shape reflects our era as vividly as the vertical church spires and stone circles did during their time? What shape most clearly defines our current worldview like Liberia's circular huts or gridded streets?

As I waited for my departing flight at London's Heathrow Airport, I watched as airplanes spiraled up into the sky and circled down, converging from all parts of the world. Blinking lights on the terminal's wall announced cities from every continent. Men in pinstriped suits brushed against sandaled women in saffron-colored saris. Newspaper headlines in Cyrillic, Roman, and Arabic letters offered different versions of the same event. The convergence of people, cultures, viruses, and ideas from all over the globe reminded me of a swirling helix—airplanes spiraling in three dimensions,

King's College Chapel, Cambridge, England, 1515

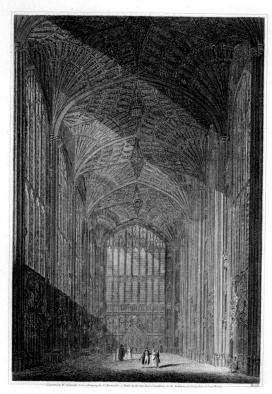

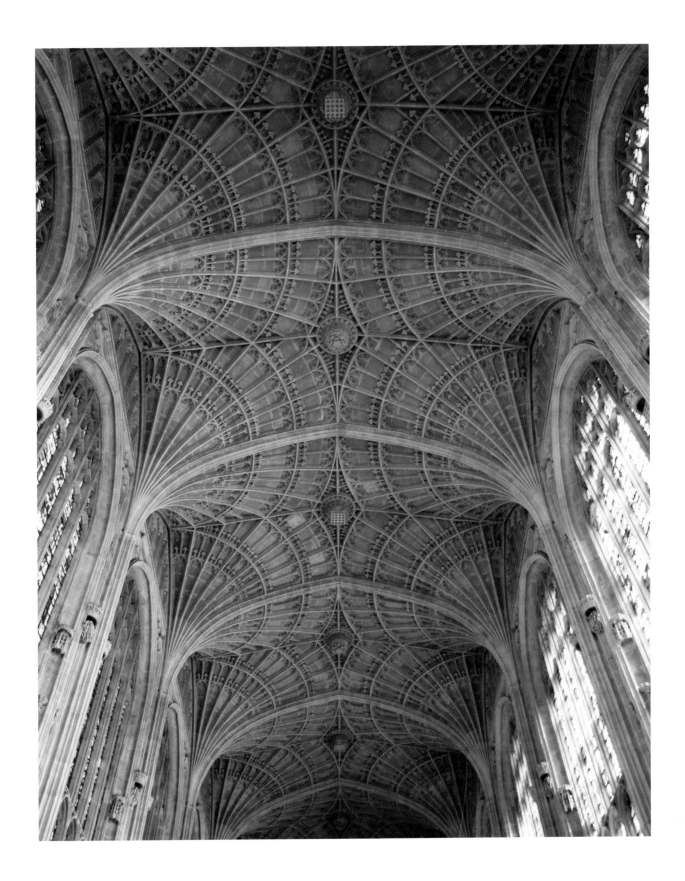

newspapers offering multiple points of view, passengers seeing from above and below.

Heathrow is also a network. Networks are made of links and nodes; and Heathrow is both a hub connecting major global cities and a link to regional airports. People and ideas continuously merge and diverge. It resembles the Internet, with infinite cross connections and wild reverberations. The swirl of a helix and the interconnections of a network match the way we engage with and view our current world.

Shaping the World

Like mental maps, shapes organize and orient our world. They provide a tangible framework for understanding a culture, its values and place in time. Shape seeps into every aspect of living—how we build our shelters, bind our social systems, form our sacred sites, and interpret reality. But at pivot points in time, the shape can change. When the shape shifts, it signals a new way of living, a new way of thinking, has entered. We can see these shifts as round huts turn into city grids, stone circles into church steeples, tribal councils into military ranks, and pyramids into networks. Shape becomes a clue to past mindsets, a way to understand the present and to glimpse the future.

Each era creates a way of organizing and orienting that works for its time. Think about the Big Dipper, the cluster of stars we connect to represent a drinking cup and handle. The image is so familiar; we use it to find the North Star and navigate the globe. The Dipper is so ingrained in our minds that it is difficult for us to look at the night sky and not see it. But it was not always so. To the Greeks and Native Americans, these same stars shaped a great bear. In Medieval times these dots connected to draw a wagon. To the Chinese, these stars formed a heavenly goddess. If we connected the same dots in the twenty-first century, perhaps we would draw a laptop computer.

We are what we build.

Each culture saw the same set of stars but connected the dots in their own way to form a familiar shape that reflected their worldview. Each version liberated a culture to navigate from the North Star while simultaneously locking them into a single viewpoint. We see a dipper so automatically that we forget there are other shapes that could orient us. The stars do

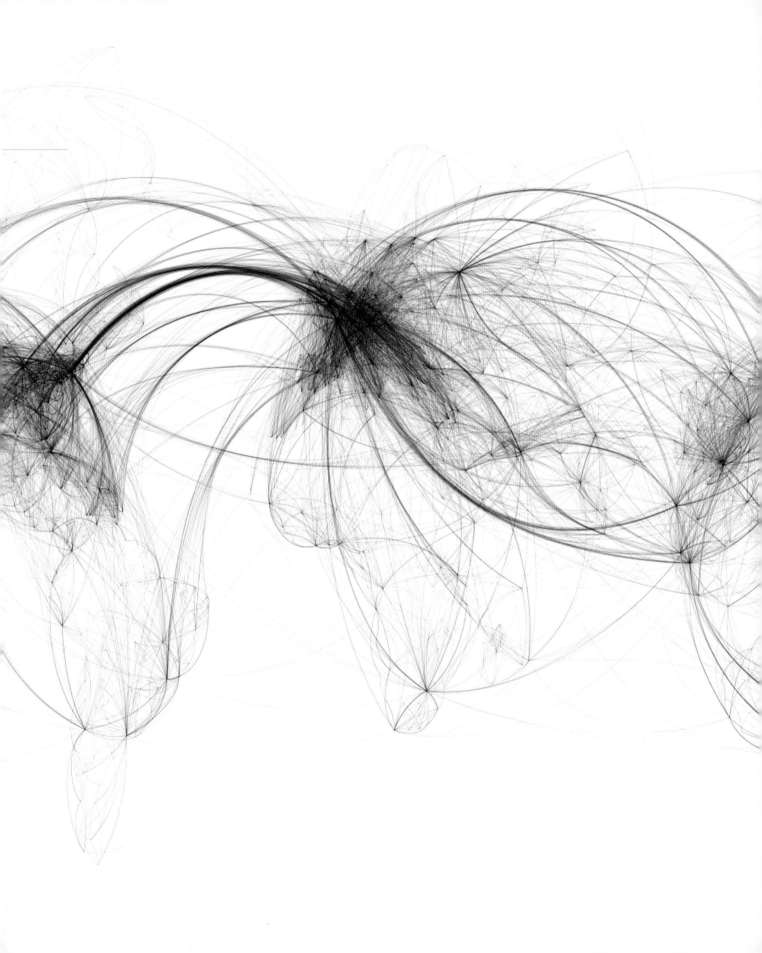

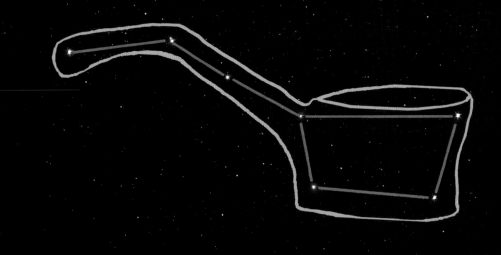

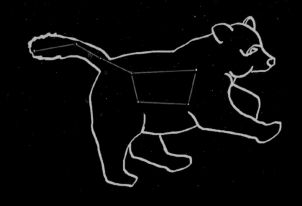

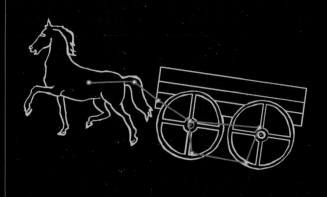

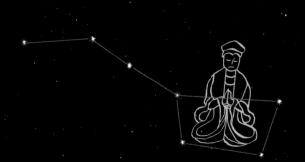

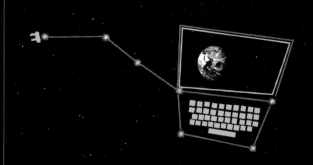

not move. We change our description of them. How we describe the world inscribes our thinking.

"We do not see things as they are,
we see them as we are."
—ANAÏS NIN, AUTHOR

Then, in migratory times, humans understood the world as interconnected, cycling and whole, like a web. Roaming bands and tribes patterned their world by seasons and sunrise. They lived woven to nature and each other until approximately 10,000 to 5000 BC. Over time, humans learned to plant seeds and grow crops, year upon year, in one spot, eliminating the need to migrate. When humans could store enough food to stay in place for four seasons, populations exploded, necessitating a new way of thinking about life and one's surroundings. The order shifted. A ladder model, organized by hierarchy, measurement, and linear progression, defines the next era of civilization. In village squares, pyramid monuments, and eventually skyscrapers, the ladder shape evolved physically. It permeates society's social tiers, political ranks, and economic classes. From ancient civilizations through the Industrial Revolution to current corporate pyramids, the ladder imprint persists.

Now, computer technology is the agent of change, spurring computation, data analysis, and interconnectivity on a new scale, leading us to the helix and network. A helix combines the circling web and the linear ladder. It revolves and evolves simultaneously. Its constant swirl matches the feeling of today's accelerated change. Thanks to the double helix of DNA, we see how past patterns and fresh combinations mix to create the new. The network follows with its infinite links and nodes leading to wild connectivity. The Internet is the master network of our lives. We even use network shapes to describe biology—the connections in our brains, bacteria, and proteins.

Next, from outer space, the lens enlarges. Satellite pictures reveal Earth as a single organism. Patterns repeat at macro and micro levels. The branching fingers of riverbeds carry the same structure as veins in a leaf and airways in our lungs. The blur from accelerated change snaps into the beauty

The Big Dipper,
The Great Bear,
The Wagon,
The Heavenly Goddess,
Laptop Computer

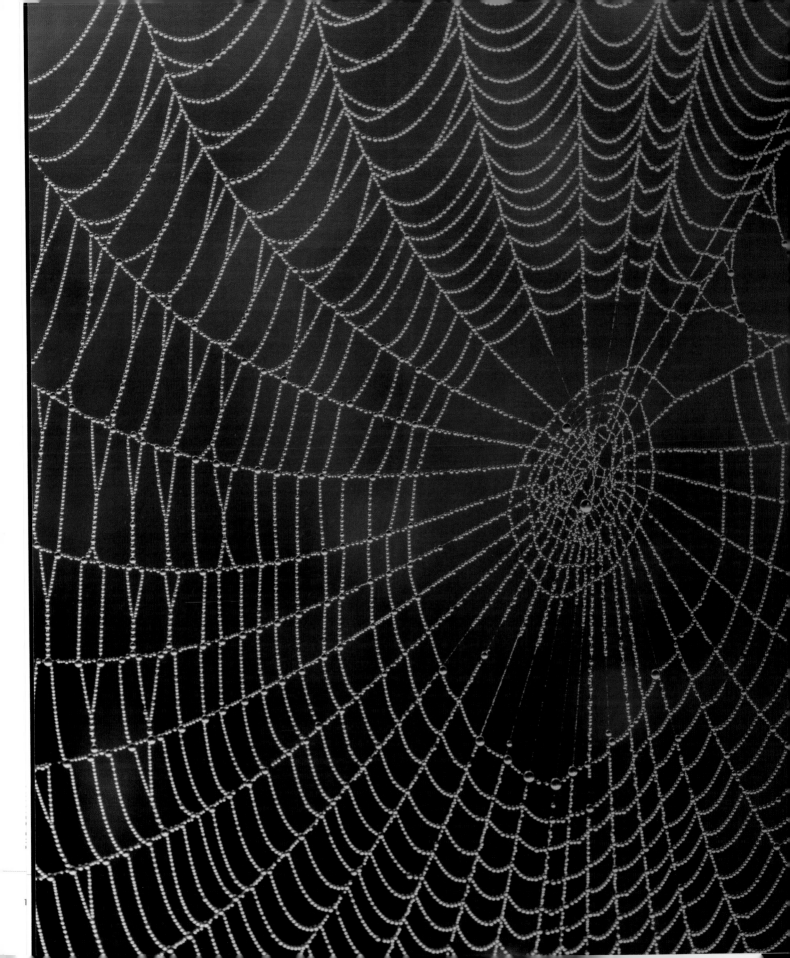

The Web

Woven to Nature's Cycles

The Earth does not belong to man; Man belongs to the Earth . . . whatever man does to the Earth . . . He does to himself.

—*Chief Seattle,*
Suquamish Tribe

Imagine roaming the prairie with a small band of fellow humans. You leave your round thatched hut or roll up the skin of your circular tent to find new hunting grounds. You look to the stars for direction. You study the path of the sun rising, crossing the sky, and disappearing at night. Tuned to the sound of animal movement, you are alert for food or danger. Knowing whether a particular berry is food or poison can prevent death. You notice the first signs of season change from wind shift, the flight of birds, or the length of shadows. The moon's expansions and contractions feel like the inhale and exhale of time itself. Whether you are standing in dense forest or on an ocean shore, watching the clouds or the tide, you feel at one with nature's rhythm. You are inseparable from nature's cycles.

The web was the mental map of humans living in migratory times. They understood reality as a repeating circle, from the daily sunrise to the annual changing of seasons. The web's hub mirrored the common identity felt within a clan. Like interwoven threads, what happened to one impacted all within the tribe. The web's concentric circles corresponded to the layers of nature surrounding them, mountains to clouds to stars. Invisible spokes radiated from the center and linked back to the hub, just as hunters left camp to venture into the forest and return.

How natural it was to imitate the shape you understood the world to be in your own shelters, sacred sites, and social systems. Around the world, early dwellings

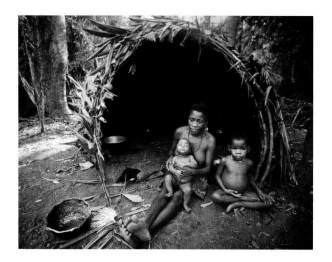

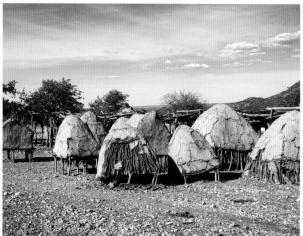

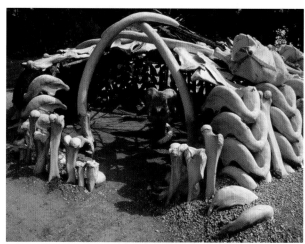

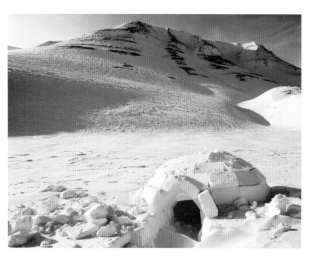

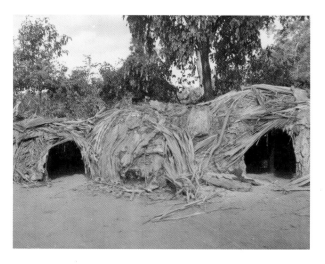

Thatched hut, Central Africa; Mud dome, Namibia;
Bent timber, Kenya; Mammoth bone dome, Ukraine;
Ice igloo, Arctic; Straw and mud sphere, Australia

Like a spider in its web, a vibration anywhere is felt everywhere.

and community settlements repeated the shape of a web, set in circles, shaped as domes, and made from whatever materials were at hand. In Central Africa, the Pygmy's grass huts resembled the cup of a bird's nest. In Namibia, Africa, mud domes dotted the arid landscape. In Kenya, tree limbs bent to enclose like a womb. In the Ukraine, the scavenged skulls, pelvises, and tusks of mammoth bones stacked to form domes fifteen thousand years ago. Near the Arctic, igloo spheres were shaped from ice. The Inuit language contains no word for *angle*, because all of nature comes in curves. In Australia, Aborigine shelters were domes composed of straw and mud. A circle encloses the most space with the least material, an ecological principle we can appreciate today.

Community compounds repeated the pattern in larger layouts. In Angola, the Kuanyana constructed circular homes, round granaries, and round cattle pens, all within a larger oval. The ringed perimeter of the Maasai's settlements in Kenya enclosed circular dwellings and round fences for livestock. Pueblo Bonito was a semicircle in New Mexico's Chaco Canyon, dotted with circular *kivas* for sacred ceremonies. Barely visible in Chile's Atacama Desert, a ring of 138 round buildings surrounded a statue presumed to have been a protecting ancestor. The Yanomami in the Amazon built a large communal ring housing four hundred people and opening to a common circular courtyard.

The pattern repeated at sacred sites. With no beginning or end, the shape of a circle symbolizes eternity and unity. Stone circles, labyrinths, and medicine wheels expressed nature's cycles. Their builders aligned the stones to mark season change, the pathway of the sun, and the position of the stars. While we have lost many of the exact words and ceremonies used by early humans, the shape of ancient sites maps their understanding of the world.

While Stonehenge is the most recognized, at least one thousand stone circles existed in the British Isles alone, and another eighty circular mounds and ditches called *henges*. Australian Aborigine rituals traced concentric circles in the sand to express their relationship to the land, the layers of the cosmos, and the ripples of time. In their way of thinking, the past, present, and future were part of a single whole. Humans' role was to maintain the world, not to change it.

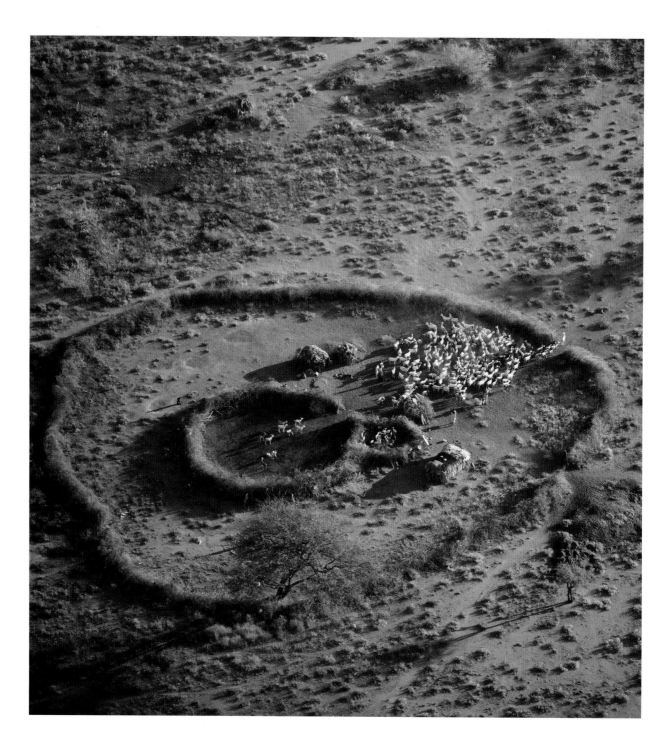

Maasai settlements, Kenya

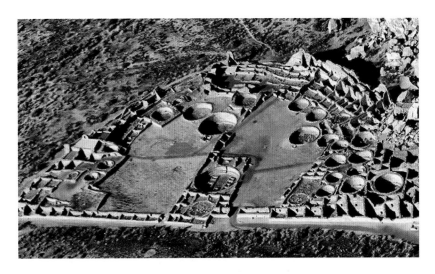

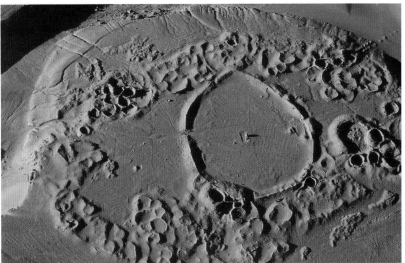

Pueblo Bonito, Chaco
Canyon, New Mexico,
828–1126 AD

Guatacondo village, Atacama
desert, Chile, 100 AD

The communal house
of the Yanomami, Brazil

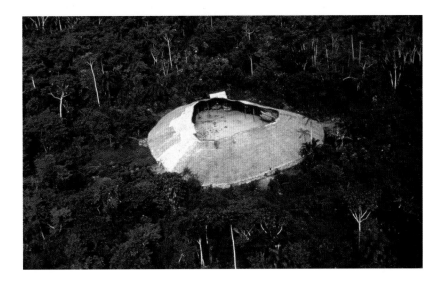

Labyrinth layouts also endured for millennia, landscaped in stone pathways, made from thread, woven in baskets, and etched in petroglyphs. What seems like a complex puzzle is actually one continuous route. The path oscillates within and between quadrants, yet it never overlaps. It carries you like a river's current to the center for contemplation. You retrace the same pattern to exit, renewed. A labyrinth is not a maze. The intention is to clarify, not to confuse.

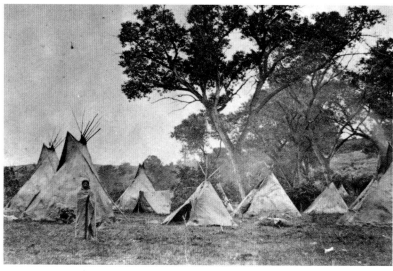

"Everything an Indian does is in a circle, and that is because the power of the World always works in circles, and everything tries to be round . . . The sky is round and I have heard the earth is round like a ball, and so are all the stars. The wind in its greatest power whirls, birds make their nest in circles, for theirs is the same religion as ours. The sun comes forth and goes down again in a circle. The moon does the same and both are round. Even the seasons form a great circle in their changing, and always come back again to where they were. Our teepees were round like the nests of birds. And they were always set in a circle, the nation's hoop."

—CHIEF BLACK ELK, OGLALA LAKOTA

Australian Aborigine;
Yellowmead Down,
England, 3200–600 BC;
Labyrinth, Spain,
c. 2000 BC;
Medicine wheel,
Big Horn, Wyoming,
c. 1200 AD

Native Americans expressed a web mindset in their sacred medicine wheels and in the construction and placement of teepees. The medicine wheels of Native Americans depicted a microcosm of the world, a sacred map. Oriented to the North Star, the wheel made it possible to navigate all directions. In sacred rituals, it aligned human life to spiritual forces for life cycle ceremonies and crises like disease and drought. Native Americans built their teepees by arranging poles in a circle, angling them together

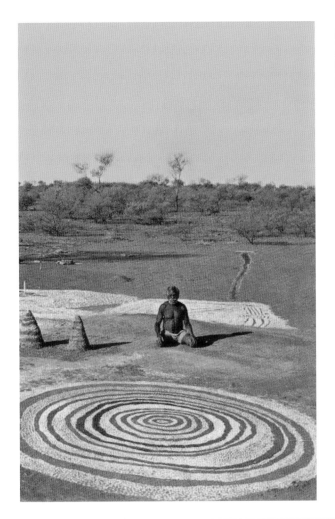

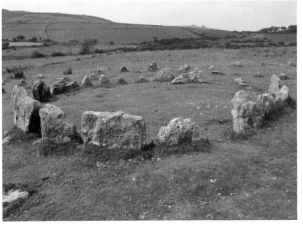

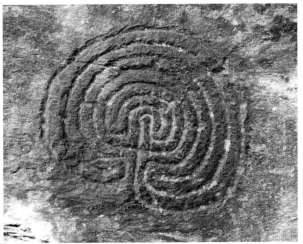

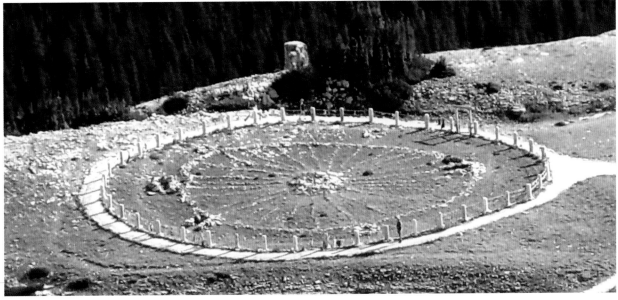

at the top, and covering them with skins. Some teepee settlements were arranged in yet another circle. The round shelters and sacred sites mirrored their connection to the whole of nature.

The Web Lens Extends

Sacred symbols also reflected the web mindset of nature's cycles and humans' place in the whole. The carriers of meaning could be as different as an insect or goddess figure, a snake or burial site, but the fundamental message of life, death, and rebirth remained the same.

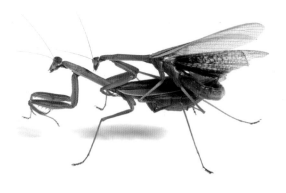

Praying mantis mating

The praying mantis was the sacred symbol of the San Bushmen in Africa. They easily could have selected lions or elephants, representing strength or speed or size, as the most revered. As keen observers of nature, the Bushmen noticed that at the moment of mating, the female praying mantis eats the male. In our psychological age, we think of this as a gender story. But to the Bushmen, it told the story of life, death, and rebirth itself. In a single instant, the male dies, the female is impregnated, and new life forms. This one symbol encapsulated the Bushmen's understanding of life, death, and rebirth. This same message exists in many religions in differing ways.

Goddess figures of all sizes were found throughout Europe. The Venus of Laussel, a goddess relief carving from 20,000 BC, depicts a female with one hand pointing to her abdomen and one hand holding a crescent moon. The carving illustrates the connection between the woman's menstrual rhythms and the rhythms of the moon. Through her body language, the goddess informs the viewer of her symmetry with nature, her personal alignment to its cycles. The Venus of Willendorf, from about 25,000 BC, is noted for her exaggerated bust and buttocks. The enlarged parts of her body symbolize fertility, birth, and regeneration. A figure with no facial features, she represents not the individual but the life force itself.

A sculpture of a goddess back-to-back with herself was found at Çatalhöyük, a site in Turkey dating around 6000 BC. On one side, she embraces a man, on the other, she holds a child. The male initiates life; the female carries new life; the child will live into the future, in another illustration of the story of life, death, and rebirth. It is also the story of time—how past, present, and future unfold as a piece of each other, as each generation links to the next.

Venus of Laussel, Dordogne, France, 20,000 BC

Venus of Willendorf, Lower Austria, c. 25,000 BC

Goddess carving, Çatalhöyük, Turkey, 6000 BC

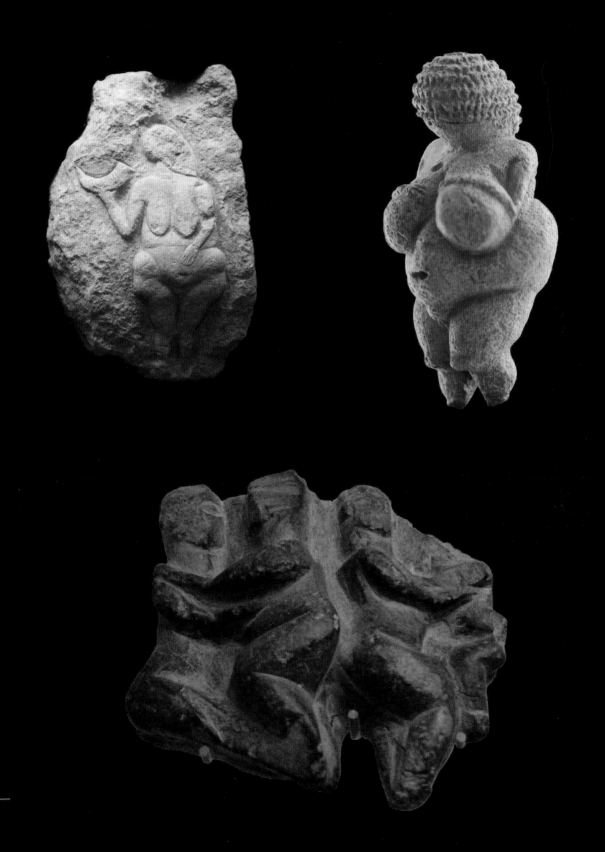

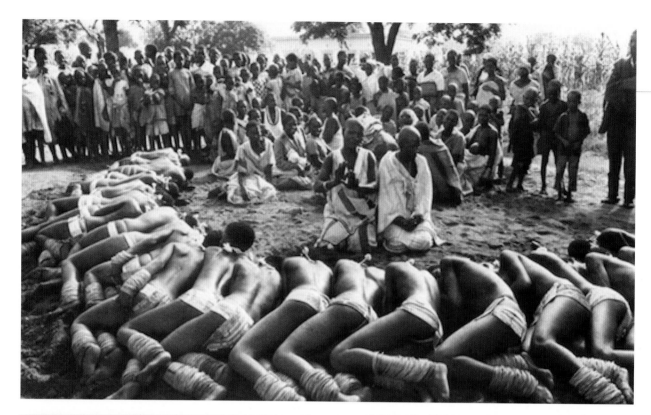

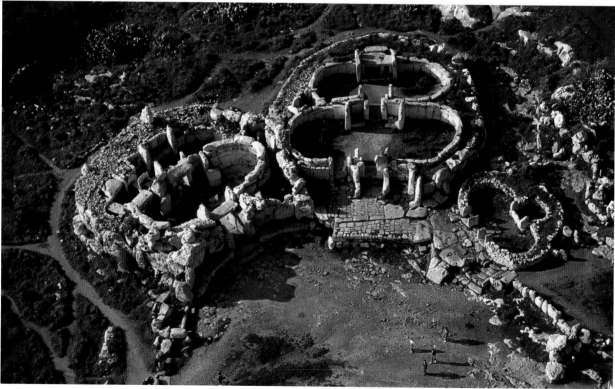

The snake also tells the story of the world as a cycle. For many cultures, the image of a snake with its tail in its mouth symbolized eternity, depicting death and regeneration as a continuous circle. The snake's annual shedding of skin and spring emergence after hibernation symbolized renewal. The snake flows; it does not step. Its movement is not linear.

Rituals are images enacted. In the initiation ritual of the South African Bavenda tribe, girls lay on the earth curled next to each other in zigzag formation, imitating python movements. They symbolically shed their childhood, as the snake sheds its skin, and emerged from the ritual as adults.

Python initiation ritual, Bavenda tribe, South Africa

Burial site in shape of goddess, Malta, 4000 BC

"Nature doesn't need knowledge, because nature is knowledge, knowledge manifest."

—MARTIN PRECHTEL, SHAMAN

Burial rituals also reflected the web mindset. In Malta and other parts of Europe around 6000 BC, burial chambers were shaped as a female body, with an entrance like a birth canal and inner rooms imitating a womb. The tomb was the womb to the next life. Around the ancient world, humans were found buried in fetal position, ready to be born into the afterlife. In their way of thinking, the sun was born each day in the east and died each day in the west. The moon was born each month,

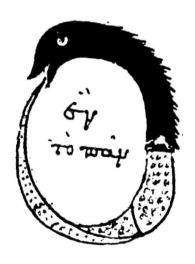

Ouroboros, symbol of eternity

Egg-shaped grave, Nitra, Slovakia, c. 5000 BC

died, and returned. The circle was fundamental to migratory humans' understanding of nature and of their own life, death, and rebirth.

Language can be as revealing as architecture, symbol, and ritual in how we shape our thinking. In the original language of the Dagara, an African tribe in Burkina Faso, there was no word for *you*. The closest word they had for *you* translates as *my other self*. In our current mindset, it is hard to conceive of a world with no differentiation between self and other. For the Dagara, the collective and the personal were inseparable. Imagine living in a world where the other is you.

———

"You are my other self."

—DAGARA DEFINITION OF "YOU"

An early Hopi language used only the present tense. While they knew the difference between yesterday and tomorrow, they regarded time as a continuous now. Many cultures regarded deceased ancestors as present in spirit. In Mesoamerica, some cultures took their ancestors' mummified remains with them when they migrated. Others buried their dead under their homes. They belonged to their ancestors as they belonged to each other. Their frame of mind understood time as an expanded present moment. The web mindset was eternally present and eternally connected.

The Bushmen of South Africa spoke to stars as if they were relatives, speaking of Grandmother Sirius and Grandfather Canis. Similarly, the Lakota American Indian expression "all my relations" applied not just to humans but also to all of nature—animals and plants, mountains and the moon. Chief Seattle of the Suquamish tribe spoke of the deer and horse and eagle as brothers; the meadow, pony, and man belonged to the same family. All creation was considered kin.

In the worldview of the web, the self and all surroundings are part of a woven whole. "The environment is not separate from ourselves; we are inside it and it is inside us," said Davi Kopenawa, a Yanomami, speaking about his people. So entwined are their lives with their environment in the Amazon rain forest that the Yanomami can distinguish between five hundred species of plants, weave silk grass for baby slings, craft pampas grass for arrow shafts, and extract salt from the ashes of the Taurari tree. In the

San Bushmen, Botswana, Africa

Yanomami tribe, Brazil

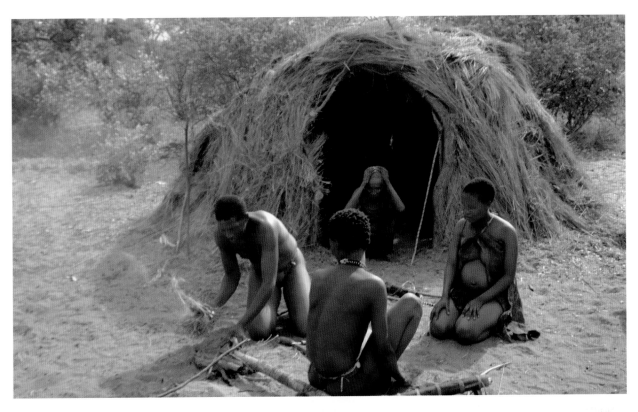

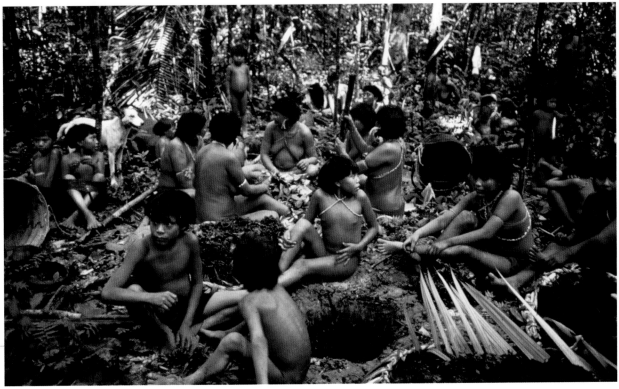

African desert, the San Bushmen can exist on water collected from the dew on leaves or the water squeezed out of dung. The Hadza in Tanzania start a fire by twirling a stick in their palms, have a whistling conversation with birds that lead them to beehives, and boil sap from a desert rose to poison arrow heads. Arctic natives navigate during their six months of darkness by judging the direction of winds and memorizing the contours of snow-covered terrain. Polynesian island navigators put their bellies on the bottom of canoes to sense wave patterns telling them the location of islands beyond sight and how to anticipate storms days ahead. Landscape is a part of identity and survival.

For early humans living on a coastline or open plains, geographies could be harsh, animals dangerous, weather punishing, and game scarce. Cooperation wasn't simply a moral ideal—it was essential to survival. Most often the hunters stalked game in teams, surrounding the animal, alerting fellow tribesmen with sounds mimicking creatures in the landscape. By custom, the hunter who downed a peccary or harpooned a whale was often the last to partake of the kill. The social equilibrium of the group trumped individual boasts. Like it or not, common efforts were a necessity for the tasks at hand. Every thing and every person had a purpose; everyone's participation was required.

Humans have survived as hunter-gatherers for more than ninety percent of our existence. This way of life prevailed from 20,000 to 3000 BC, until foraging shifted toward early farming. Reality was a circle without end, defined by the rising and setting of the sun, the waxing and waning of the moon, the cycle of life, death, and rebirth in generations and seasons. Early humans understood themselves as embedded within this larger circle, inseparable from the animals or stars or each other. Their mental map was a web.

Constants Change

When I visited the Serengeti on a safari in Tanzania, I felt like a dot in the landscape, insignificant in the vast expanse of the African plains. Yet I felt inner peace in knowing I was not in control. At home in the city, I navigated via the GPS on my phone or the street signs. I assumed I was always able to control my environment. In the wild, nature is in control, and that often frees the mind to experience nature's beauty and balance. Of course, this peace assumes safety. Seeing nature from the seat of a jeep offers the

protection and privilege of an enlarged lens—being able to step back and see the whole.

On the safari, I watched two lionesses stalk a wildebeest and kill it by choking its neck. They dragged it back to their six cubs, who hugged their mothers' necks, grateful for dinner. I observed the hunt not knowing which animal to root for. One wildebeest went down, but there was no diminution of wildebeests in the landscape. It gave its life to support further life. Watching the circle of life on the open plains, the balance of it all shone through.

I sat in comfort and safety, present but not a participant. I was not hunting for my family's next meal. I was not at risk at every moment from beasts or broken bones, from flash floods or poison flora. For early humans, this hunting scene was not an amusement, but a necessity of daily survival. They would have imitated the quiet stealth and decisive action of the lioness. Humans have learned to control nature enough to live in relative safety from the wild, but we have lost some joys of feeling a part of nature.

Imagine what a jolt it was for humans who lived in nature for millennia to find themselves in modern life. Those experiencing the transition from living close to nature to living in urban areas must have felt a sense of loss. The few indigenous cultures that remain today give us a glimpse of how surreal urban life feels from a tribal upbringing, and how strange and impossible living in a rain forest or desert plain seems to the modern eye.

In 1988, a Maasai warrior, Tepilit Ole Saitoti, wrote about his traditional Maasai childhood and his introduction to modernity. As a young boy, he was the first from his settlement to be sent to boarding school. At the end of his five-day walk to the school, he heard a noise. He had been told of things called cars but had never seen one. He asked, "Do they trot, gallop, or walk?" On his first visit home from school, his brothers were incredulous that Tepilit and another boy who had learned to write could decipher scribbles on a sheet of paper. When Tepilit correctly read the writing on the other boy's paper, the brothers said, "These boys. They are prophets. They are prophets." Years later, when traveling to Chicago, he wrote to his father saying, "Poor moon. Though so close to the earth, people here hardly notice it. Stars and the moon are not necessary here. You know how much we long to see the new moon." What a leap it was to go from moonlight to streetlight, from fireside stories to reading written words, from animal howls in the jungle to the honk of traffic.

The contrast between nature-centered and human-centered cultures is starkly seen in the conflict between Native Americans and American pioneers. Buffaloes sustained Native American life on the plains. Every part of

the dead animal was repurposed——meat to eat, skin for shelter and clothing, bones to dig, tendons to tie. Nothing was wasted. As both a war tactic and sport, it became US government policy to eradicate the buffalo. In one winter between 1872 and 1873, 1.5 million buffalo were killed. Buffalo Bill Cody alone exterminated four thousand buffalo within two years. Passengers shot them from the window of moving trains. The systematic extinction of the buffalo was intended to undermine Native Americans both physically and spiritually. The buffalo were part of their identity and survival. Killing the buffalo killed the culture as much as any major battle, and many Native Americans did not make the leap to the new way of life.

Connections can break as the shape of our reality evolves from a web to a ladder mindset. The skills of the shamanic healer do not translate into those of a medical doctor. The wise elder who maintains community equilibrium is not likely to become a civil judge. A child raised in a compound of kinship, freely wandering to the best cook at mealtime and the best storyteller at sunset, cannot wander freely in a city looking for food and comfort from a stranger. The sudden entry to a modern world assaults family, community, valued skills, and one's very identity. As the mindset shifts, reality shifts. Transition can be cataclysmic.

"Modern man has lost the sense of wonder about the unknown and he treats it as an enemy."

—LAURENS VAN DER POST, AUTHOR

Web to Ladder

A way of life rooted in the constants of nature seemed destined to endure without change, but change it did. Humans went from nature-centered survival to man-centered settlements, from roaming to a fixed room. A new order arose. Gathering turned to planting, images on cave walls to written words, councils to commands, round huts to square homes, fireside circles to social ranks. Goddesses were replaced by gods. The idea of progress

entered our consciousness. Maintaining the earth was no longer enough: We now sought to improve our surroundings.

The triggers of change seemed simple enough when they emerged—a field of oats or corn growing each year in the same place, an indentation of lines on wet clay recording barley trade, a horse tamed for riding, an ox tamed to pull a plow, a corral built for goats. Yet each entry developed into entirely new ways of feeding, valuing, trading, building, and organizing. The shape of thinking shifted.

As crop experimentation led to permanent settlements, the migratory way of life that existed from the emergence of Homo sapiens 200,000 years ago changed radically. It happened at differing times in different continents. Wheat and barley were first harvested in Mesopotamia around 10,000 BC. In Mesoamerica, maize began to be cultivated around 7500 BC, with squash and beans following. Millet became a staple crop in Northern China by about 6000 BC. It was as impossible to predict the monumental changes agriculture would bring, just as it was impossible to know at the time of its birth what a dramatic effect the Internet would have.

The first attempts at farming were not a clear-cut and immediate success. For early humans, hunting, undertaken mostly by males, was not always successful and often dangerous. Foraging, mostly a woman's task, provided the steadiest source of food. Early farming likely seemed a risky undertaking, as droughts, floods, and insects could wipe out months of work. Yet over time, farming became more successful, and for the first time a surplus of food became available. Once humans could store enough food in one place to feed a group through four seasons, migration was not necessary. The nomad bands of tens and then the seasonally migrating tribes of hundreds eventually began to form permanent settlements, then villages, and then towns and cities of tens of thousands.

The change in food supply triggered a domino effect on all aspects of life. Populations exploded. Records were needed to keep track of food production, storage, and exchange. Writing as we know it today was introduced as a form of bookkeeping. It spurred measurements of trade, records, and construction of civic and irrigation projects. To organize both the workforce needed for massive engineering feats and to order life with larger populations, hierarchies emerged. Tiers and ranks arose in social classes, divisions of labor, and political power.

In this new hierarchical mindset, humans began to think of themselves as separate from the animal world and in control of the natural order. Animals became beasts of burden to carry water, plow land, and trek

mountains. Sheep and goats were domesticated and corralled near family compounds to provide meat, wool, and milk. Cattle were owned and wealth counted by their heads.

A man's strength was needed for plowing, taming animals, and lifting stone. Men became the primary source of feeding the family. Women who had once ventured out for gathering, a surer source of food than hunting, now stayed closer to their homes with less participation in the food supply. A subtle change at first, this new dynamic introduced a much larger social shift. Women in early societies enjoyed an egalitarian status, not out of morals, but because women gathered the food and every person's participation was required in the many tasks of survival. When farming began, males became the source of food. Power switched mostly to males—in governance, sacred stories, and households.

Domestication of animals, Bonda, India

In the web era, individuals needed to know a wide range of skills to survive—thatching grass, stalking animals, poisoning arrows, and navigating by stars. But settled humans had to manage larger populations in one location. Jobs specialized to the needs of urban life: metalworker, farmer, craftsman, or mason. A man learned one skill and practiced it throughout the duration of his life and then passed that skill to his sons.

Individuals began to define themselves not by land or clan but by job. This shift was reflected in the names people gave themselves. The Bushmen called the stars Grandmother Sirius and Grandfather Canis. Native Americans gave their daughters names from nature that translated as Eternal Blossom or Forest Water. As life shifted from living within nature to man controlling nature, names began to reflect an individual's relationship to their craft or trade: Carpenter, Miller, Baker, Wheeler, and Mason.

Cuneiform was one of the earliest forms of writing. Wedge marks indented into wet clay kept track of trade, taxes, and tributes, the number

of men in a workforce, and the amount of barley exchanged. This writing produced another subtle but significant change: Cuneiform was written in lines, row by row, on square tablets. The straight marks were opposite in shape and purpose to the round medicine wheels and stone circles that were used to invoke spirit, heal, and align to stars. Circles express wholeness; lines divide the whole into parts.

Writing eventually expanded from recording trade to recording language itself. The oral storytelling of bands and tribes bonding around a fire, listening to tales of how their people came into the world or recounting a great hunt, gave way to written text. Information from the animated human voice, delivering stories memorized over generations, now came through static, impersonal, and permanent inscriptions.

In web societies, images were understood by all. Drawings on cave walls or body paint or carved wood totems and masks held symbolic messages the whole tribe understood. After writing entered, only the literate could read the text, a sharp division of power that intensified hierarchy. A priest interpreted what God was saying and a king declared the law. The one who could decipher the text was often the one who decided what it meant—for his own advantage.

The shift from images to text changed social and sacred systems in a way no one could have predicted. As writing evolved from keeping track of barley trades to keeping track of human behavior, the written word became the carrier of both law and holy writ. By 1750 BC, the Babylonian king Hammurabi inscribed a written code of laws on tall stone pillars. Above the lines of text was an etched image of their god giving King Hammurabi the laws. The image showed law as a gift from the divine, passed to a ruler. The divine and the ruler were lone individuals, both males. The tribal council disappeared. Tribal justice focused on reconciliation, not retribution. Restoring harmony in the community was paramount. Written laws often focus on punishment, not the restoration of relationships. Authority was transferred to inscribed words governing behavior between men, between a ruler and his population, between God and humans—each separate from one another.

The word "history" itself refers to the *written* story of humans. "Prehistory" refers to all that happened before the introduction of writing. Writing was such a pivotal change that all before it is relegated to guesswork from archeological clues and a few remaining indigenous cultures. That leaves out over ninety percent of human existence on this planet. Historic texts make it all too easy to forget that history is written by the last person at the tablet—or the typewriter—and is often a one-sided tale told by the victor.

Cuneiform tablet allocating beer, Iraq, 3100–3000 BC

Sumerian account of silver for the governor, Shuruppak, Iraq, 2500 BC

Cuneiform tablet from an Assyrian trading post, Anatolia, 1875–1840 BC

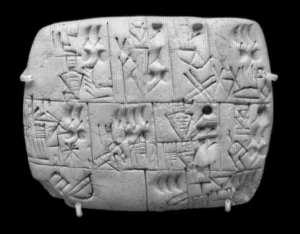

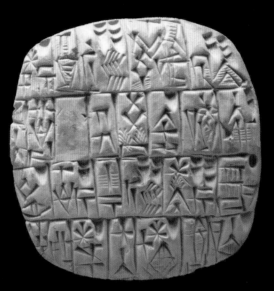

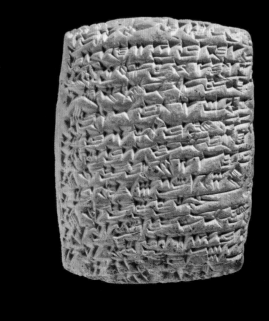

Psyche found ways to accomplish her tasks and still preserve relationships. The web ideas of community, cooperation, and alignment with nature are heroine solutions. The hero mentality, influenced by a ladder mindset, views the world as duality and solves problems by force. As the ladder worldview entered, the hero was in charge. He moved to the top of the ladder.

Think of the word *legend*. As a deeply rooted story, legends guide a culture. On a map, a legend is a guide to measurement. Both help us shape our relationship to each other and to the world around us. Story legends gave way to metric legends of ladder thinking as societies moved from qualitative to quantitative mindsets.

The shift from foraging to steady agriculture occurred at different times, yet the sequence remained the same. Web societies looked for order within nature and found it in nature's interwoven, circular patterns. Slowly, nature went from being the sacred source to the material resource. In just a few thousand years, the focus shifted from nature to man, from a woven web's collective to a hierarchical ladder.

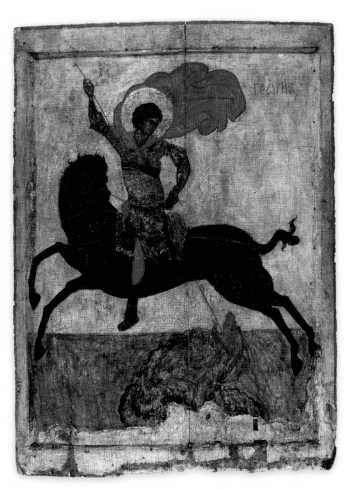

Opposite: Goddess as Chaos

Left: Hero tames nature

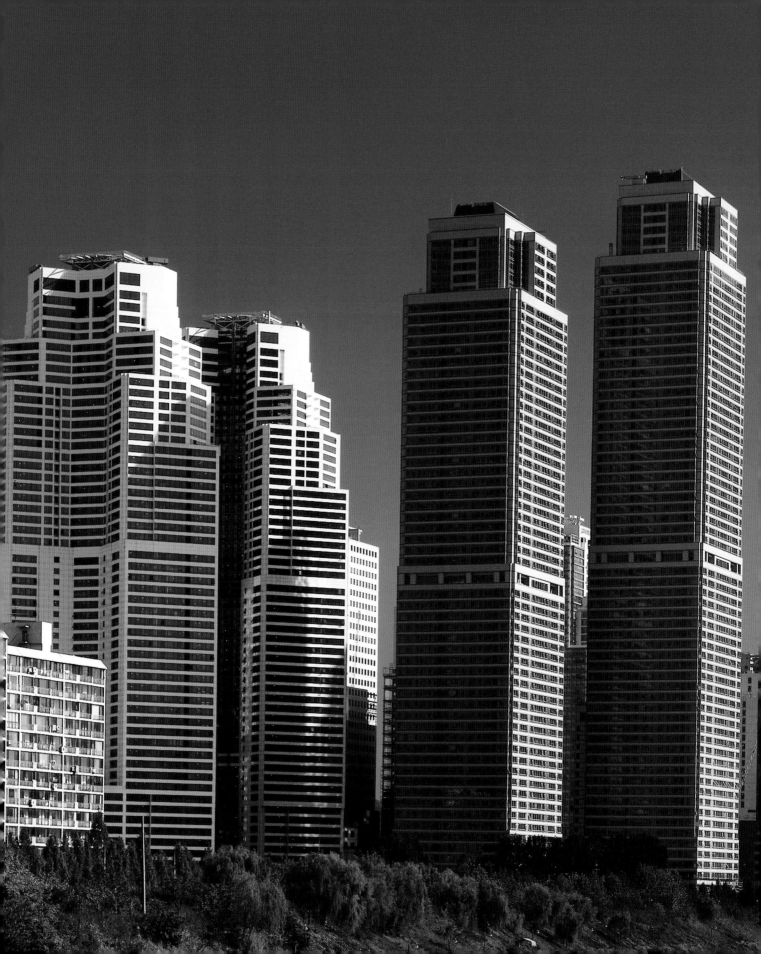

The Ladder

Hierarchal Order

The king is in the counting house, counting out his money . . .

—Sing a Song of Sixpence

I filmed a documentary in Abu Dhabi in 1969, at the beginning of its catapult from a sheikdom of Bedouin nomads to a modern metropolis. Goat-hair tents dotted the desert just outside the town. Men in white robes with falcons on their arms stepped into their Mercedes-Benz cars, ready for a desert hunt. Abu Dhabi consisted of a handful of blocks, with one hotel a few stories high. Yet it bustled with builders from all parts of the globe.

I was an unfamiliar sight, an American female in my twenties, wearing western dress. The day of the filmed interview with Sheikh Zayed, the leader of Abu Dhabi, he asked me, "Will you tell this story from your head or from your heart?"

I replied, "Both, I hope." But his question was more important than my answer. He guided his land and people at a time when his world was in transition from qualities to quantities, from meaning to metrics, from web to ladder. Within a few decades, Abu Dhabi zoomed from nomadic tents to skyscrapers so high they look down at the clouds.

A ladder has power at the top. Each rung is either higher or lower than another. It is a binary form—up/down, yes/no, right/wrong, win/lose. Its straight lines offer only one route to the peak—no byways or alternatives. Decisions move downward from the top. The ladder mindset tells history as a story of progress, not a recurring cycle. It values goals and efficiency. Things do not count if they cannot be counted.

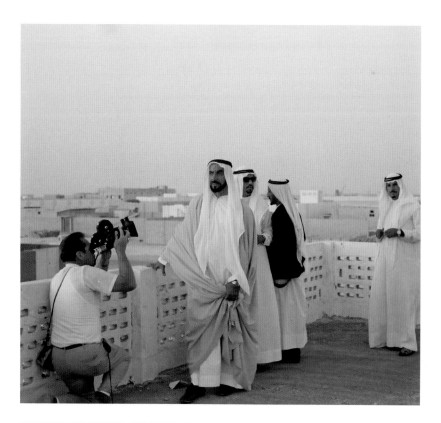

In the transition from web-era wanderings to walled towns, permanence replaced migration. Brick buildings replaced thatched huts and skin tents designed to be rolled up for travel. Fixed, written laws overtook group decision making. A new order arose to manage larger populations. Hierarchy replaced the collective. Kings replaced kinship. Ranks of laborers replaced teams of hunters. Stratified social classes pushed out the equality of bands and tribes. Size itself drove new solutions. The efficiency required to organize and build was made possible by one thought: Measure everything.

Ladder characteristics evolved through three shapes: the square, pyramid, and grid. Combined, these three shapes form the new mental map of the ladder. At first, town squares replaced circular settlements. Soon, a pyramid model entered in monuments, political ranks, and economic tiers. Finally, in the Industrial Revolution a grid emerged in assembly lines, downtown street corners, and the graphs of business and science.

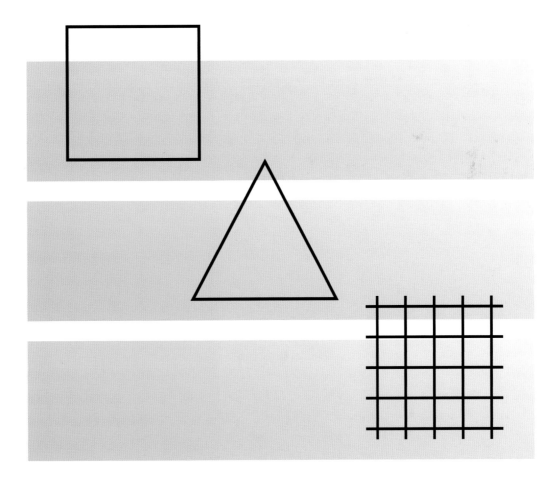

The Square: Lines and Right Angles

Imagine yourself in one of the first permanent settlements, with square or rectangular village walls surrounding rectangular homes made of rectangular bricks. At the center of your village is a town square, not the round hub of a circular encampment. You build homes and streets with straight lines and right angles. They look like the square units between ladder rungs.

The four walls are built to protect you, your harvest, and your goods. They form a square representing safety, separation, and measurement. It must have felt good to manage the wildness around you, store enough grain for winter, and be safe from wolves and enemies. Though new comforts enter, kinship with creatures and the environment fades.

Life in the town square led to new economic opportunities and new specialized jobs—blacksmith or tax collector, bread baker or brick maker. But it also locked you into economic and social ranks. Your value was now measured by what you manufactured and the status of a political appointment, not your contribution to the harmony of the community.

The idea of private property emerges for the first time. Migratory humans would have found it strange to think of owning land, as today we might think it strange to own the rights to air or water.

The four cardinal directions, once known by spokes on the circle of a medicine wheel pointing to the North Star, aligned early humans to the cosmos and the natural world. In permanent settlements, the gates on town walls also represented the four directions. But for settled humans, those directions led the way to trading partners and political allies—manmade matters, not cosmic relationships.

Ladder shapes first popped up in the Indus River Valley, Mesopotamia, and Egypt. Farming and settled life developed over five millennia. In 7000 BC, inhabitants of Jericho, Israel, built brick homes in the city famous for its defensive walls. In 6000 BC, Çatalhöyük in Turkey housed more than six thousand permanent residents packed together like Legos. By 3100 BC, Egypt was a kingdom; the pyramids started appearing in 2650 BC. By 2060 BC, ziggurats emerged in Ur, Iraq. By 1200 BC, villages coalesced into major cities in Mesoamerica.

The earliest towns were Harappa and Mohenjo-daro, both located on the shores of the Indus River between India and Pakistan. Planned cities had wide, straight

Hattusas, Turkey, 1200 BC

Mohenjo-daro, Pakistan, 2600–1900 BC

Harappa, Pakistan, 2200–1900 BC

Fortress at Jublains, France, 200 AD

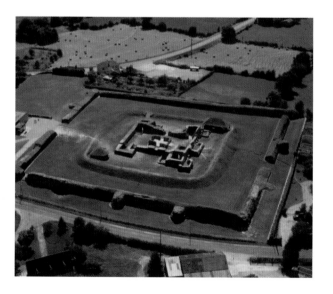

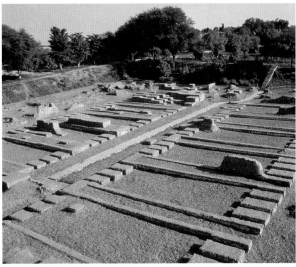

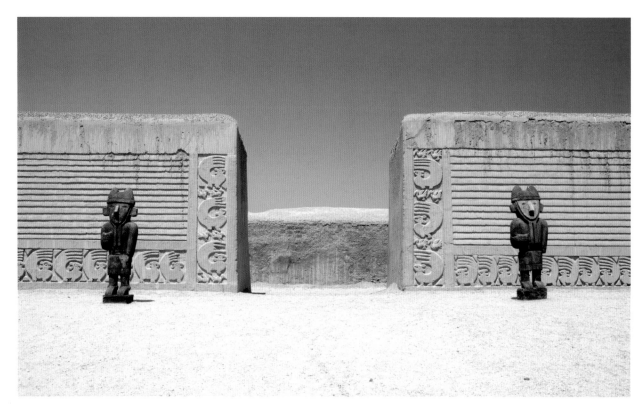

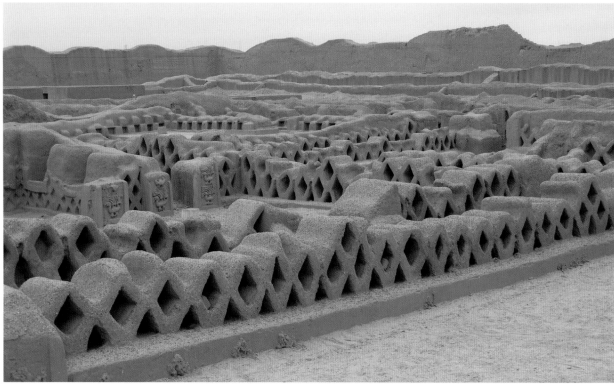

streets and a crude sewer system for populations of thirty thousand. Rectangular bricks of uniform size formed three-story buildings, and a canal system irrigated wheat and barley crops. Rectangles and square walls from 1344 BC are visible in the remains of the Turkish town of Hattusas, from the Hittite warrior culture.

Hop around the globe to Chan Chan, Peru. With a population of more than thirty thousand, spread over twenty square kilometers, the city is laid out in rectangles, surrounded by a fifty-foot-high protective wall. The main entrance opens immediately to another tall wall, then a warren of linear pathways. The template is a maze meant to confuse invaders, far different from the labyrinth, whose single unfolding path leads you to the center and returns you renewed. Chan Chan thrived around 850 AD, later than the Middle Eastern and Indus Valley cities, but it followed the same sequence of development. As irrigation made a steady food supply possible, subsistence living turned into urban expansion.

In the first urban sites, the use of measurements developed rapidly, with the need to plan for more people and larger civic projects. The produce from a harvest required intensified quantification at each step of bundling, weighing, distributing, and exchanging. Weighing balls and balancing scales became the common denominator in the trade and storage of commodities. Sumerians developed an abacus system, where beans or stones move in grooves cut into sand or on tablets of wood, stone, or metal. Babylonians were so sophisticated in math that a few simple lines and symbols on wet clay could calculate the square root of two. The Peruvian Inca counted by knots in a thread on a *quipu*, enabling them to add, subtract, multiply, and divide, to keep track of taxes, labor output, economic produce, and population.

As absolute as we think arithmetic is, math systems can vary, based on the number two or ten or twenty or sixty. Like different languages describing the same object, or different drawings connecting the stars of the same constellation, numbers reach the same conclusion through a different lens.

Entry walls and
interior maze,
Chan Chan, Peru,
850–1470 AD

The Pyramid: Hierarchy

Around 4000 BC in Mesopotamia, a Sumerian would have looked up in awe from the base of a ziggurat's steep steps, built in receding levels, with a flat top for rituals. These were holy structures, the first of their kind. But he could not climb up to the top. The highest tier was reserved for the priests alone. The Sumerian could visit the monument to pray and to trade, as the public area at its base became a center for social life. At times of seasonal rites, trading intensified. Merchants and craftsmen brought their products. Farmers came to sell wheat and buy a sharper plow. Each city was home to a different god residing in its central ziggurat. The Sumerian's identity was now tied to his home city, which supplied his god, livelihood, and social system.

As cities expanded to empires, greater attention was given to authority and efficiency by using hierarchical structures—both physical and social. The pyramid shape came into prominence amid this first massive burst of population growth and persisted thousands of years, continuing even into our contemporary age in the form of corporate and government bureaucracies. Pyramid monuments from this period are so massive that they still endure. The pecking order also endures from the top down through political tiers, labor ranks, religious priesthoods, and social classes.

The tip of the pyramid monuments pointed to god above, in the heavens, beyond our reach. Heaven and Earth were severed. In the ladder era, the divine was transcendent, above, not immanent, within all things. Pharaohs, kings, and emperors were half human/half divine. As god/kings they mediated between god and humans. Only the ruler and priests had access to the gods. The king set the laws, and the priests told you what god was saying.

Perhaps it is no surprise that the word *ruler* applies both to the authority at the top and the measurement of things. Strong knowledge of math and engineering was required to construct these massive monuments. An Egyptian pyramid's organizational chart mirrored the structure itself: from one pharaoh and one vizier to many overlords to a workforce of twenty thousand.

Around the world, pyramids popped up as populations enlarged. Throughout Mesoamerica they had flat or stepped sides, sharp or curved edges, yet all expressed the same understanding of the essential order. The steep steps to the top intimidated and inspired. In Guatemala, Tikal's site contained five different structures aligning to each other, to the stars, and to the seasons. In Mexico, Chichen Itza resembled an annual calendar, with ninety-one steps on each of its four sides plus the one step to the top

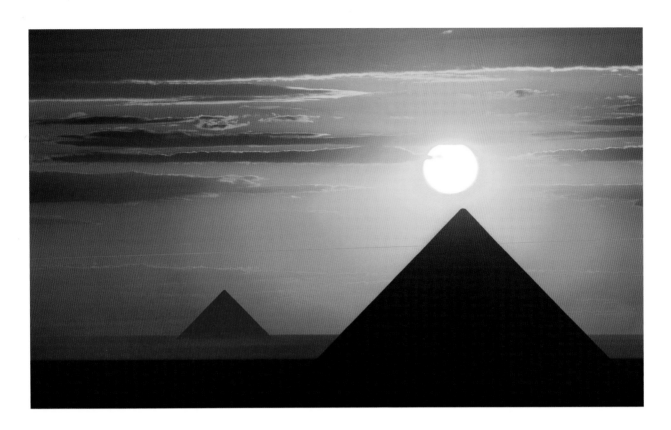

Pyramids of Giza,
Egypt, 2560 BC

platform equaling the 365 days of the year. It also marked the solstices by a snakelike shadow winding down its steps. At Teotihuacan in Mexico, the public space between the sun and the moon pyramids was large enough for 150,000 to gather.

Humans in all eras are trying to figure out their relationship to all of creation. Stone circles and medicine wheels were early attempts at an answer to their place in the universe. Pyramid monuments responded to this curiosity with massive structures, more engineering knowledge, and more labor forces to construct these buildings.

In Sudan, over one hundred pyramids appeared, starting in 2600 BC and continuing for millennia. They were built closer together and their peaks formed sharper angles than the Egyptian monuments nearby. In both Egypt and Sudan, the pyramids held deceased kings and queens. The forms varied but not the message of pyramid hierarchy in governance, views of the divine above, and the belief in an afterlife.

The form also recurred in Asia. In Java, Indonesia, the Borobudur Temple was shaped like a mountain, the natural abode of ancestor spirits. In India, the Peruvudaiyar Temple displayed the emperor's vision of his own

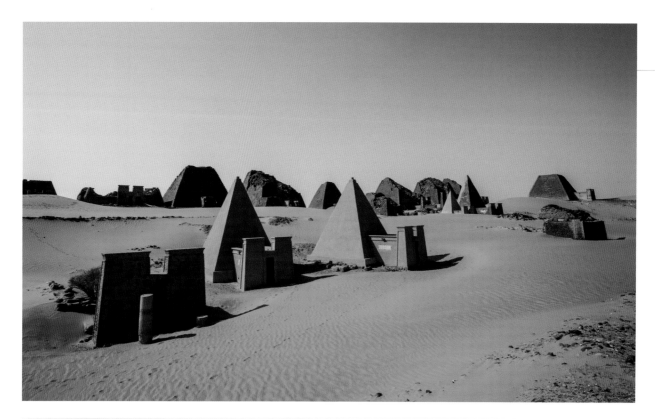

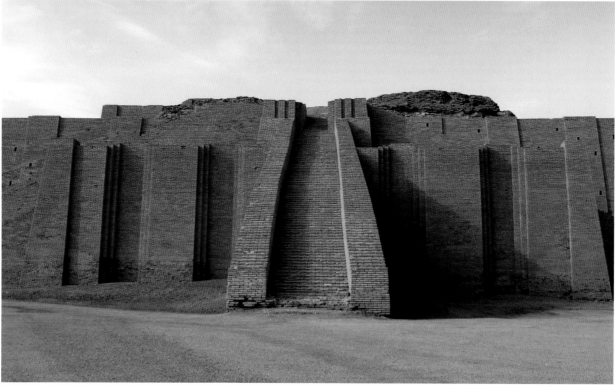

Nubian pyramids,
Sudan, 300 BC–350 AD

Ziggurat at Ur, Iraq,
c. 2100 BC

power, his relationship to the universal order, and his link to the transcendent god Shiva. In Cambodia, the temple complex of Angkor Wat, with coned spires pointing to gods above, began as a Hindu temple and transformed to a Buddhist sacred site.

In cathedrals and churches, spires and steeples pointed to heaven like directional arrows. Steep interior columns, vaulted ceilings, and ceiling ribs arched like hands in prayer all aimed at a god above. The facades of many major cathedrals also read like a triangle, with slanted sides emphasizing the peak at the middle.

The pyramid's ladder qualities later influenced the creation and proliferation of skyscrapers, massive monuments dedicated to corporations rather than a god. CEOs are the new pharaohs and kings. The pyramid also lingers in management structures within corporations and countries, where authority rests at the top and relays down rungs of a ladder. However, new management styles fold into our current world—team tasks, feedback flow, listening as well as deciding. Those stuck in pyramid structures too tight find themselves out of business, whether by bankruptcy in commerce or political revolutions in countries.

A ruler at the top of the ladder has been the template for millennia, from kings to father-knows-best in families. Now we're beginning to reshuffle the deck. E-commerce start-ups scramble for grassroots traction with apps catering to the need of the customer. Corporations need ideas bubbling up as well as down, as innovation races faster than ever. Input from all sides and sources is needed in a global marketplace.

We see these changes in daily headlines as if they grew like mushrooms overnight. But the ladder's need for a pecking order, clear rules, and rulers does not go away. The shape shifts. It morphs into the grid with repeating squares. It's still about measurement, just like a ladder. Yet the center or point of origin is nowhere to be found.

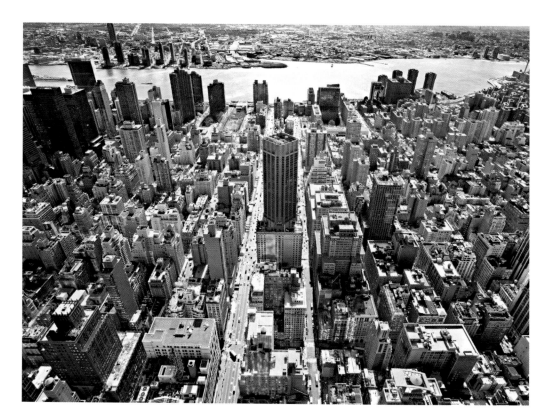

Aerial views of
New York City

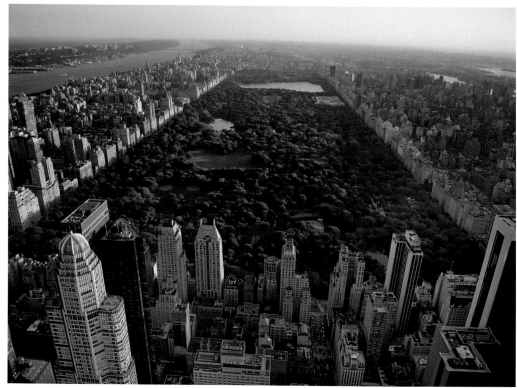

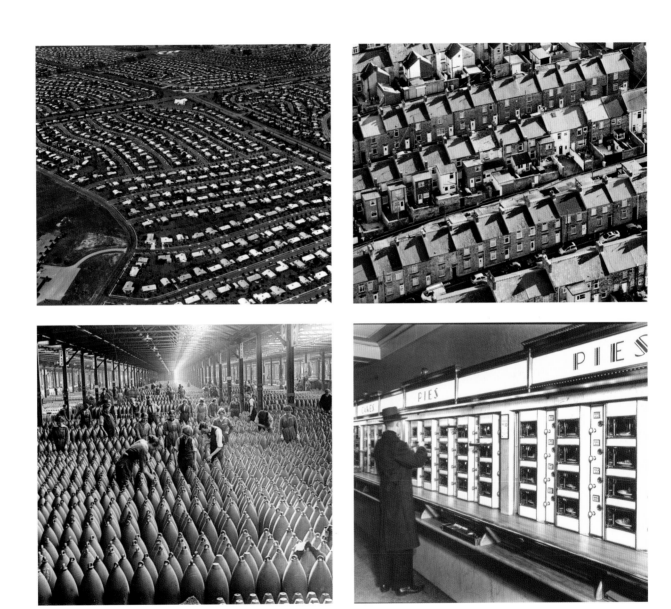

Levittown, Pennsylvania, 1950s; English row houses

Munitions factory, England, c. 1917; Automat, New York, 1950s

pro
the

zor
wh

sta
hou
eve
in
of t
Th
erin
hab

is s
stor
dat
the
min
grio

line
it w
fror
elec
righ

race
pur
the
Bur
Wo
high
for
look
time
will

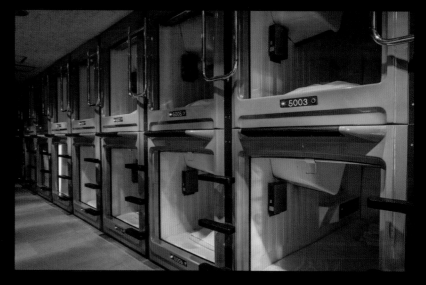

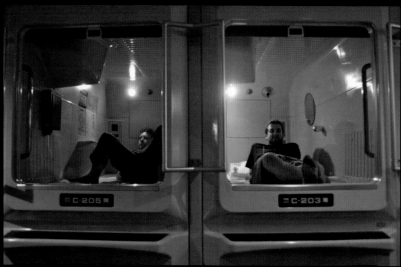

But notice a change. Microsoft, the master of ladder measurements, created headquarters in Redmond, Washington, that is low, built close to the ground. It hugs the earth, not the sky. Its three-hundred-acre campus holds forty buildings, but none are high-rises. The campus contains soccer fields, volleyball courts, multiple eateries, and large open spaces supporting community life. Microsoft is the master of ladder measurement, creating software that lays the foundation for the connective revolution. As computational metrics accelerate, they change our relationship to each other. Power shifts to the number of connections rather than the measure of height.

The disease of the grid is growth gone wild. It has the characteristic of a cancer, as malignant cells replicate unchecked. The ladder mentality, like Ford's assembly line, is to add more, make it bigger, and make it more efficient, as bottom lines measure success by higher numbers. But air pollution, scarce resources, contaminated water, and drought have brought this shape to its limits. Sustainability reenters out of the need to survive.

Lines to Swirls

At the beginning of the shift to ladder thinking, attention was focused on the storing of grain, the safety of walls, and the expansion of trade spurred by advanced counting. Craftsmen become tradesmen, then merchants, then global corporate brands. Political order evolved from kings and emperors to CEOs. At first the ladder was used in square village layouts and to engineer massive pyramids. Thousands of years later, as the shape replicated itself into a grid, the latter mindset offered a framework for industries to build and produce exponentially.

The ladder mindset has infused our minds, buildings, cities, science, commerce, warfare, and culture for millennia. The ladder represents logic, progress, proofs in equations, a steady road, and a promise of arrival at a sure and permanent answer. It facilitated the evolution from drawing on cave walls to the printing press, from chariots to steam engines, from cuneiform to Photoshop, from sailing ships to space stations. Ladder measurements enabled great architecture, science, medicine, manufacturing, and grand metropolises; they continue to help us compare, plan, organize, and orient. But the shape we impose on the world can fit so well for a time that we mistake it for reality itself.

A personal conversation with United States Army General Norman Schwarzkopf drove this home for me. I asked him, "Why do humans go to

Capsule hotels,
Japan

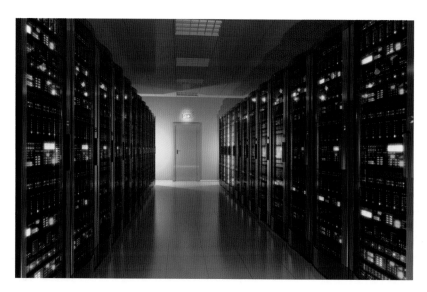

Cloud storage servers; and
Electrical power grid

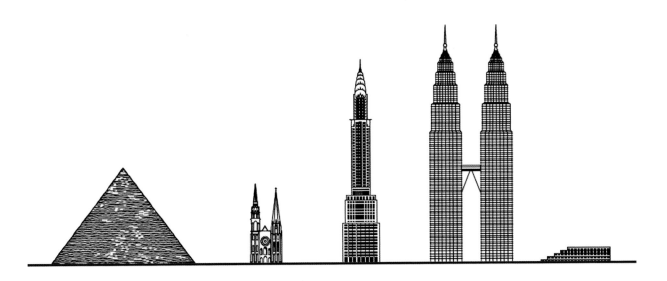

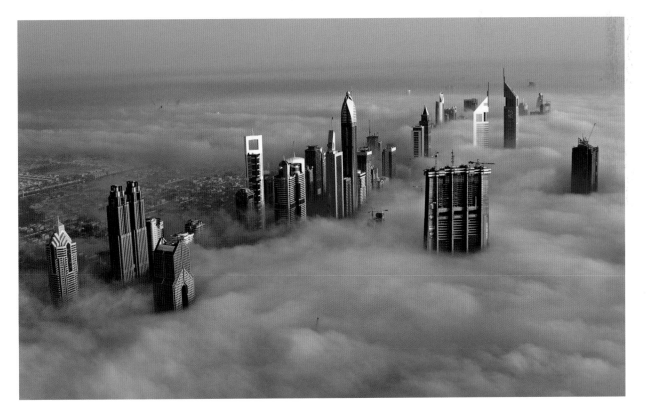

Top: Timeline of iconic buildings: Great Pyramid of Cheops, Egypt, 2600 BC;

Chartres Cathedral, France, 1200 AD; Chrysler Building, New York, 1930;

Petronas Towers, Malaysia, 1997; Microsoft Headquarters, Redmond, Washington, 1986

Bottom: Skyscrapers looking down on clouds, Dubai

war?" His succinct answer was, "Straight lines." He was referring to colonialists drawing lines onto the map of Africa and the Middle East without regard to the location of differing tribes, religious sects, and water sources. The Alamo's proverbial line in the sand, the Mason-Dixon Line, the Berlin Wall, and the Korean DMZ all created dividing sides. As we move toward a more connected, highly integrated future, we need a more flexible shape to accept multiple points of view.

The ladder mindset relies on absolutes and clear dichotomies, which appear increasingly unstable and arbitrary in our emerging world. Clinging to this shape puts us at risk of ignoring or discounting the meaningful fluctuations, bifurcations, and instabilities of our ever-changing, high-speed era.

The grid, the most recent iteration of the ladder mindset, continues to shape our thinking, worldview, and our built environment in innumerable ways. Many of us were taught the periodic table of elements as a grid, in linear sequence, giving an impression that this is how the world works. This shape locks us into a world of squares and right angles, leading us to imagine chemicals lined up like soldiers in right-angled pods. But the very same sequence of elements can also be drawn as a helix or as loops or as a doughnut shape, called a torus. Nature does not change. The map in our mind changes. Remember how some cultures saw the stars of the Big Dipper and connected them to look like a bear or a wagon? The stars did not change, only our description of them changed. Our surest ways of knowing and orienting are still partial truths, one approach, not absolutes.

In Panama, the F&F Tower is an almost perfect replica of a helix. It rises from a square base, a hybrid of old and new, reminiscent of the pyramids. Its fifty-three stories of glass and concrete office floors spiral atop a square garage. The helix top spins and stretches toward the sky—part web and part ladder.

History is not neat. It oscillates, overlaps, and overreacts. In web times, access to spirit came through dance, communion with nature, drumming, shamans—any number of subjective thoughts and processes eventually replaced by the rationality and logic of the ladder and deemed mere "superstitions." The science of ladder measurements aimed at truth, accuracy, verification, and standardization. Yet clinical trials also allow for a placebo effect, recognizing that belief alone can trigger an effect. In the Middle Ages, ladder hierarchy allowed for great castles and cathedrals. But the emphasis on divisions and either/or thinking led to the Inquisition and Crusades. Each time held its virtues and defects.

In keeping with the ladder way of thinking, human history is often

The periodic table
as grid and helix

→	1	2	3	4	5	6	7	8	9	10	11	12	13	14	15	16	17	18
	1 H																	2 He
	3 Li	4 Be											5 B	6 C	7 N	8 O	9 F	10 Ne
	11 Na	12 Mg											13 Al	14 Si	15 P	16 S	17 Cl	18 Ar
	19 K	20 Ca	21 Sc	22 Ti	23 V	24 Cr	25 Mn	26 Fe	27 Co	28 Ni	29 Cu	30 Zn	31 Ga	32 Ge	33 As	34 Se	35 Br	36 Kr
	37 Rb	38 Sr	39 Y	40 Zr	41 Nb	42 Mo	43 Tc	44 Ru	45 Rh	46 Pd	47 Ag	48 Cd	49 In	50 Sn	51 Sb	52 Te	53 I	54 Xe
	55 Cs	56 Ba		72 Hf	73 Ta	74 W	75 Re	76 Os	77 Ir	78 Pt	79 Au	80 Hg	81 Tl	82 Pb	83 Bi	84 Po	85 At	86 Rn
	87 Fr	88 Ra		104 Rf	105 Db	106 Sg	107 Bh	108 Hs	109 Mt	110 Ds	111 Rg	112 Cn	113 Uut	114 Fl	115 Uup	116 Lv	117 Uus	118 Uuo

Lanthanides	57 La	58 Ce	59 Pr	60 Nd	61 Pm	62 Sm	63 Eu	64 Gd	65 Tb	66 Dy	67 Ho	68 Er	69 Tm	70 Yb	71 Lu
Actinides	89 Ac	90 Th	91 Pa	92 U	93 Np	94 Pu	95 Am	96 Cm	97 Bk	98 Cf	99 Es	100 Fm	101 Md	102 No	103 Lr

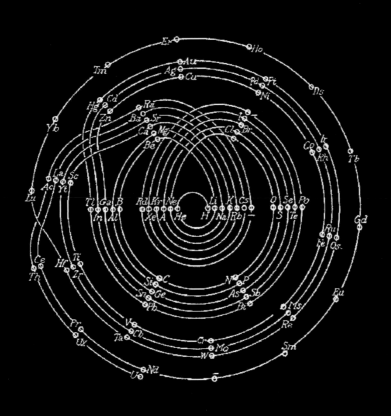

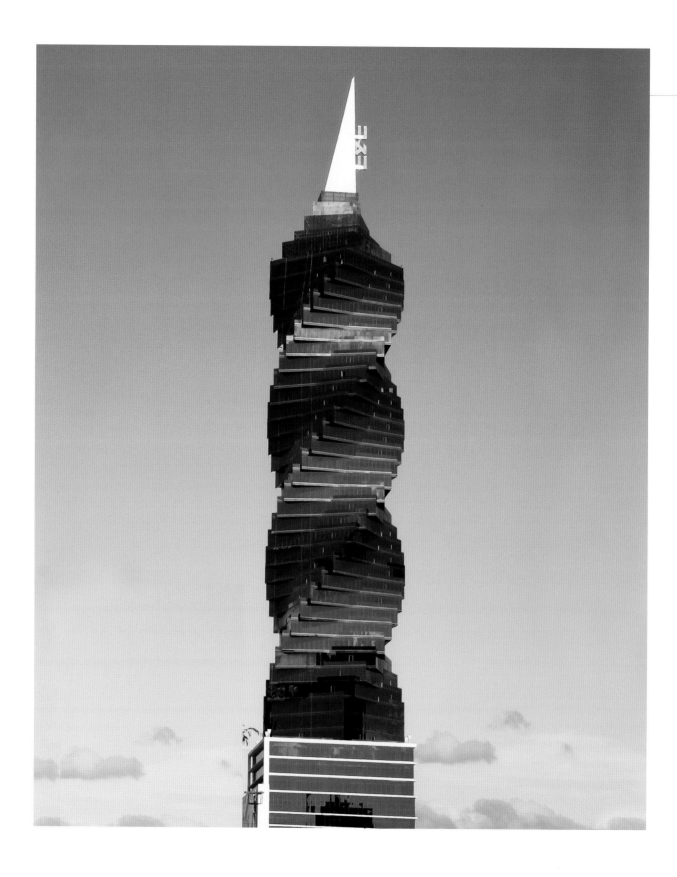

told as a series of wars. But it can also be told through the lens of ideas or inventions: introductions of new systems—agriculture and writing to machines and electricity to computers and genomics—that upend the last way of living, sometimes gradually and sometimes within a decade. These discoveries change everything about our lives: our mobility; our jobs; our experience of cities; our exposure to other cultures; our ways of learning, trading, and relating; and our health. Ultimately they change the way we see the world. They reshape our mental map.

How we describe the world inscribes our thinking. We can be liberated or locked by how we connect the dots. As the mental map changes, the lines of a ladder begin to curve, not only in structures, but also in social systems, in new forms of commerce, and in new ways of relating. People once gathered in the village square, and then at seasonal festivals in front of a pyramid monument, and then in the slow-moving traffic within the downtown grid. Now, we move into an age where they gather remotely, at digital hubs, and communicate electronically, without ever needing to meet face to face. At our hinge point in history, the shift from a ladder to a helix mindset is as pivotal as the shift from web to ladder.

Part III | NOW

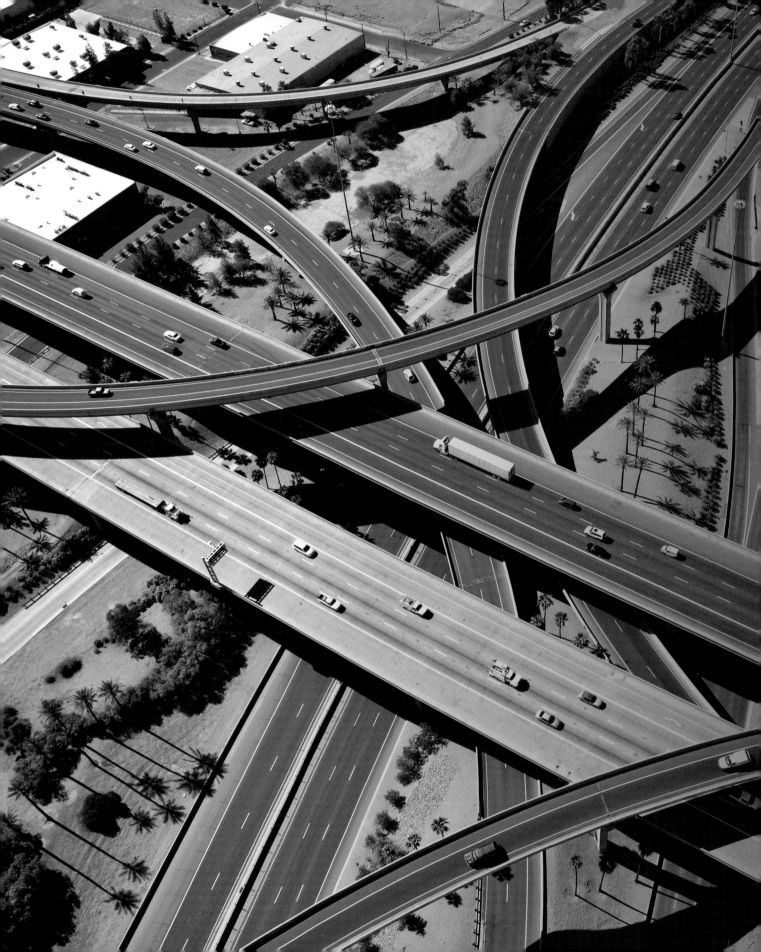

The Helix

Spiraling to the Next

> The real voyage of discovery consists not in seeking new landscapes, but in having new eyes.
>
> —*Marcel Proust*

I navigate the tiered highway loops that cluster like spaghetti in bowls in major cities. Ramps lift me from the ground onto curving bridges, sometimes higher than four-story buildings, and drop me back to earth headed in a new direction. The road may lead north before it exits south. Drivers crisscross lanes in a silent dance of moving parts. My planned route requires noticing a jumble of signs—letters and numbers, the names of streets nearby and cities far away, of state roads and interstate freeways. The weave of layered, spinning ramps is a dizzying swirl, like the eddies of a river's current.

To orient myself, I look for the pattern. From a bird's-eye view, the highway loops form a helix—spiraling in three dimensions, seeing from all sides, and spinning to new territory in unpredictable ways. Using the mental map of a helix, I navigate a moving system. A helix curves like a circle, but it always evolves, swirling around an invisible open core in the center like an unseen essence that holds the same pattern through variations. The shape combines elements of both the web and the ladder—shapes that came before. Like a web, the helix is circular. Like a ladder, it progresses. It simultaneously revolves and evolves, holding both pattern and the unpredictable.

In the ladder mindset, cultures needed clear directions of ahead or behind, up or down. But as we evolve, we need a perspective that offers multiple angles. The curved helix reminds us there are no straight lines in

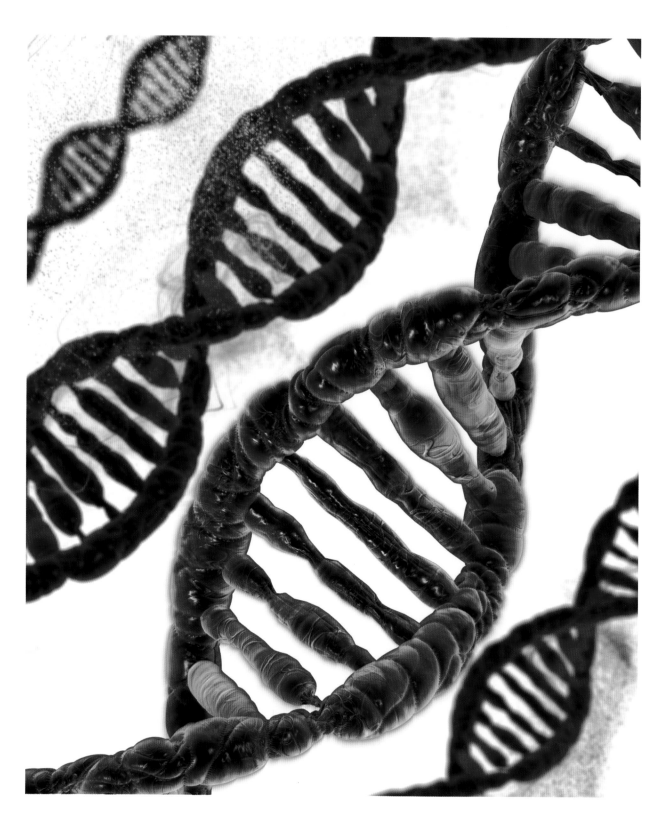

Double helix of DNA

nature. There is momentum in a spin. Change intensifies. Transformation is constant. We learn to see in three dimensions, with many lenses, and we expect surprises. The helix blends all that has come before and holds the possibility of not just one but many different outcomes.

"Patterns cannot be weighed or measured. Patterns must be mapped."

—FRITJOF CAPRA, PHYSICIST

A helix is the shape of transformation in nature. It appears at all scales, from stars to genes, as forces and living forms blend, unfold, and adapt. Spiral galaxies are the nurseries for new stars. Hurricanes spin in a helix, at once destroying the old and clearing territory for fresh growth. Water swirls in a vortex, attuned to the Earth's hemispheres. Leaves sprout off the stem of plants in helical formation, allowing each an open angle to the sun. Your fingerprints may reveal a helix—your unique identity within its universal pattern. You are both one of a kind and one in kinship.

The helix way of seeing, building, and thinking first began to appear in 1953, when James Watson and Francis Crick identified the structure of DNA as a double helix. Imaging played a large part in the discovery of DNA as a double helix. Scientists in different laboratories around the world were trying to discover the structure of DNA. Some thought it may be a three-stranded helix. Rosalind Franklin, an x-ray crystallographer, created an image that suggested DNA was a double helix. This observation led their team to be first in uncovering the correct structure.

In the double helix of DNA, old patterns mix in unique combinations. Genes from parents and ancestors pass to children, yet the newborn arrives as its distinctive self. You do not know what your unborn children will look like, yet you do know they will carry information from your genes. What *was* is not entirely lost. What *will be* cannot be exactly forecast. The double helix of DNA answers the riddle of how things can recur without repeating.

We are connected to the human family in the expanse of time. In DNA, humans are ninety-nine percent the same, yet no two humans are genetically identical. Over millennia humans adapt to their environment in distinctive ways. The long, lean bodies of the Maasai give them height to spot

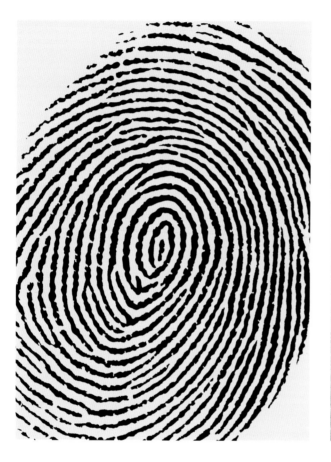

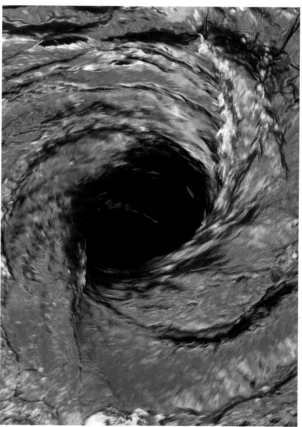

Human fingerprint, Water vortex,
Hurricane, and Spiral galaxy

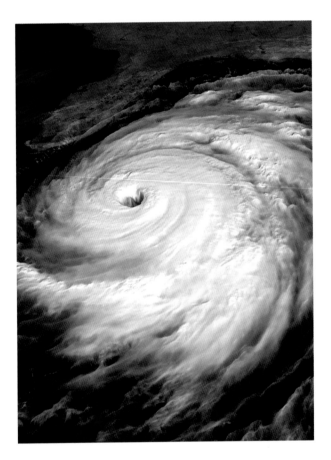
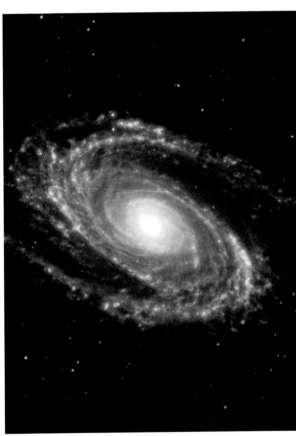

danger from afar on the Serengeti plains. The Pygmies' short stature allows easier movement in the dense, low foliage of Central Africa's jungles. The helix of DNA holds pattern of a different sort: Unlike the grid, it incorporates adaptation.

"We are not the stuff that abides, but patterns that perpetuate themselves."

—NORBERT WIENER, ORIGINATOR OF CYBERNETICS

The double helix of DNA tells the story of life, death, and rebirth through science, the language of our time. Yet it is essentially the same story that web cultures knew in nature's cycles. From their viewpoint, the sun was born each day, died each night, and returned; the moon grew round, contracted, and expanded again; the seasons cycled. Abundant evidence showed that life appeared, receded, and reappeared. This cycle was symbolized in the snake shedding its skin; in the mating praying mantis representing death, birth, and new life; and in goddesses of regeneration. What *is* will die, though something from it will live on. The past, present, and future are entwined.

The web mindset of early humans viewed the world as an eternal cycle. The ladder mindset regarded evolution as a linear progression in which the strongest survive. The helix mindset regards evolution as creative adaptation—a continuous response to a changing environment. Survival of the *fittest* changes to mean *what fits a situation*. The helix models these adaptive qualities, where flexibility, oscillations, and mixtures push to new expressions.

We Are What We Build

Scientific advancements brought us to the discovery of the helix, which in turn allowed us to see nature with new eyes. Within the same decade, the form began to disrupt ideas in many fields. By 1959 this new shape appeared for the first time in architecture. The Guggenheim Art Museum in New York City opened—a building coiled in a helix. Frank Lloyd Wright

Guggenheim Museum,
New York, 1959

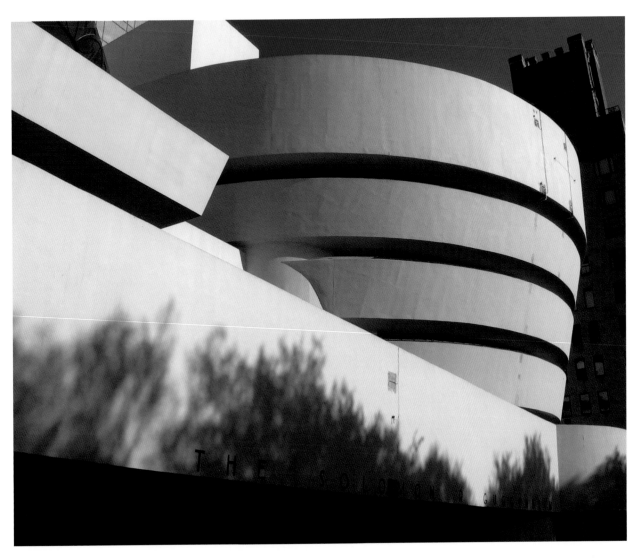

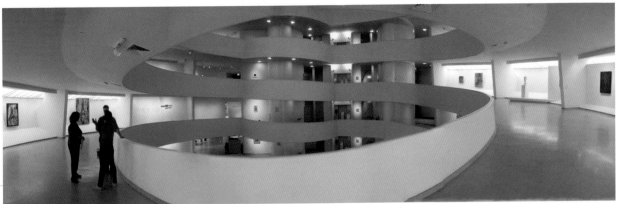

Spiral township,
Auroville, India,
1968

designed this structure with a small circular base that enlarges as it swirls up. It is not a series of square galleries. The interior is one spiraling floor that ramps like an apple being peeled in one turn. Walking up or down the spiral, you experience the entire building at once through its open core. From the inner rail, your eyes can scan the full retrospective of an artist's work in a continuous glance. The widening center acts as both the hub of a web and the line of a ladder.

Auroville, India, a township founded in 1968 and dedicated to the guru Sri Aurobindo, is also laid out as a helix. The pattern expresses egalitarian, spiritual principles. In the core stands a golden temple. From this center, sectors of the town curve out in spaces dedicated to organic farming, green industry, or cooperative living. Unlike the wagon wheel design of Washington, DC, or Paris, where streets radiate in straight lines from a city center, Auroville unfolds like a flower, following organic curves rather than ruler lines.

In Singapore, two large green twisting arms enfold the Nanyang Technological University's School of Art, Design and Media. These grass-covered roofs curve in a helix, serving as a park. Underneath is a multistoried glass building. The green structure blends into the landscape as gracefully as a thatched hut on an African plain.

Computer-aided design (CAD), made possible by ladder measurements, brought about an architectural breakthrough by making irregular shapes easier to communicate and construct. It cracks the shell of cigar box buildings, where rectangles repeat in the form, facade, and floor layouts. With computer drawings, right angles more easily become convex, concave, and flowing forms. Metal sheets bend like sails in shifting winds, mimicking nature's oscillations in the Walt Disney Concert Hall in Los Angeles. The architect Frank Gehry developed both the design and new technologies to accomplish the complex curves.

The Niterói Contemporary Art Museum in Brazil spirals up to a saucer-shaped building floating over the bay across from Rio de Janeiro. The architect, Oscar Niemeyer, spoke of his intention for the form to emerge from the ground and continuously grow and spread like a flower rising from the rocks. A residential building in Chongqing, China, is composed of stacked and staggered discs, twisting like the spiral rotation of leaves sprouting from a stem to allow each apartment's balcony an open angle to the sun. A parking lot designed for Miami, Florida, mirrors a helix formed by discs. Each floor of a proposed hotel in Abu Dhabi spirals upward in a

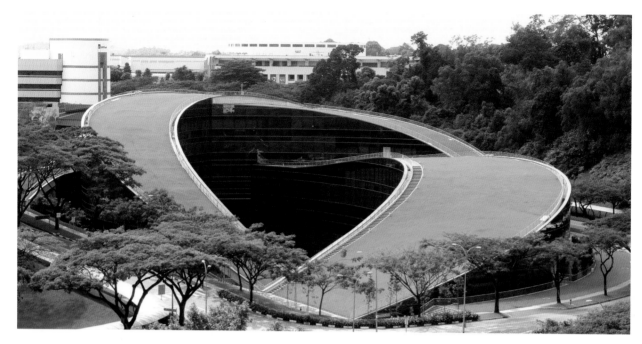

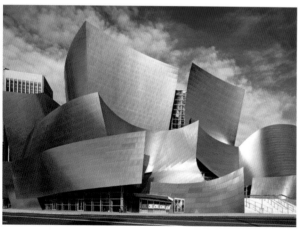

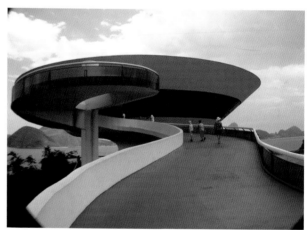

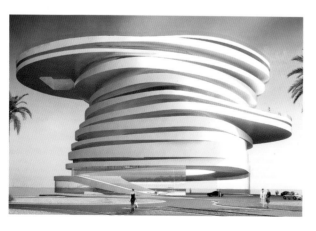

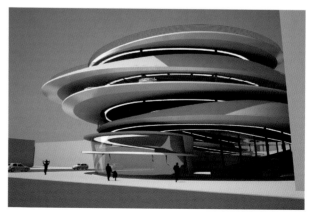

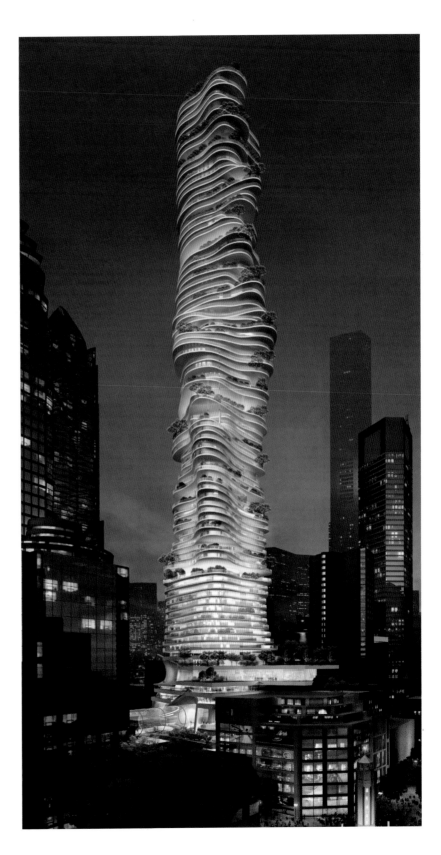

Grass-roof helix, Nanyang
Technological University,
Singapore, 2006

Walt Disney Concert Hall,
Los Angeles, 1996

Museum of Contemporary Art,
Niterói, Rio de Janeiro, Brazil, 1996

Proposed project, Abu Dhabi

Parking lot, Miami, Florida

▶

Proposed project,
Chongqing, China

new direction. These helical buildings vary in style and size, but all express the world in a spin.

Ancient fortress walls and town gates once were the attractions in Baku, Azerbaijan. The Old City was divided into *quarters*, the very word reminding us of a divided square. These quarters segregated areas for nobles, sailors, blacksmiths, or merchants. In contrast, the newly built Heydar Aliyev Cultural Center by Zaha Hadid resembles a field of waves, replete with organic curves inside and out. The building's swirl in space and form mirrors the contours of Bedouin tents, Islamic calligraphy, undulating sand dunes, and rising waves.

Old town gate, Baku, Azerbaijan

Heydar Alyeiv Cultural Center, Baku, Azerbaijan, 2012

"Sometimes I don't like the fast changes, even inside myself—but I can't help it because I change my surroundings and my surroundings change me."

—AIDA MAHUMDOVA, DIRECTOR OF AN ARTISTS' COALITION IN BAKU

Swirls in Culture

Innovative architecture helps us see how our world is changing, alerting us to new ways of structuring society and perceiving our lives. As we saw in the web and the ladder, the shape of our time seeps into every aspect of society. A blending of races, a spectrum for gender, and a fusion of foods emerge. Legal outcomes can be determined by mediation, arbitration, and conflict resolution, instead of traditional binary win/lose conclusions. Businesses include team tasks and feedback loops in decision making. Medicine addresses whole body systems, not simply body parts. The helix swirls all parts into one overarching system.

Even dance, decision making, and health reveal the shifts in thinking through time. Dance postures in tribal web cultures hunker low and close to the ground, as if drawing energy up from the earth. Circle dances are the most common, where each person is an equal participant in the whole.

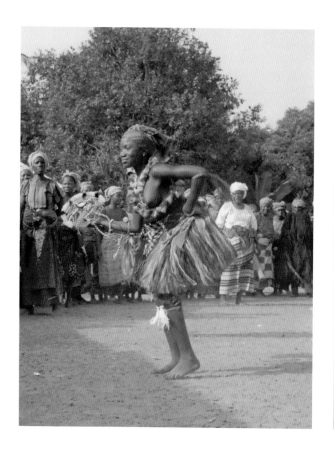

African dance, Classical ballet, Breakdance

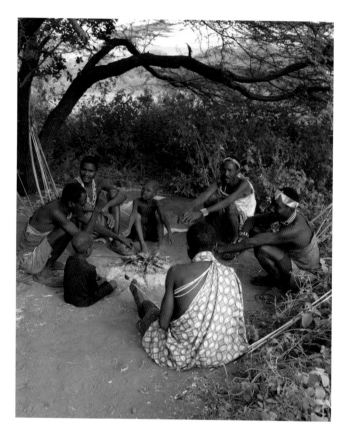

Tribal council, Corporate hierarchy, Samsung boardroom

Natural herbs, Modern surgery, Holistic healing

to the World Future Society, Ken Olsen, the chairman and cofounder of Digital Equipment Corporation, said, "There is no reason for any individual to have a computer in his home." Four years later, the IBM PC hit the market, and in a few short decades, computers are not only in homes—they're running them. Our iPads, smartphones, watches, and all the emerging devices are essential to daily life.

But in the whirlpool of change, not all are carried by the current. The digital divide sharply cuts off opportunity for those without access to computers and high-speed Internet. Those who cannot afford the connection, do not know how to use it, and are without equal access to jobs, education, and government services. In some American cities, this is thirty percent of the population. By missing this boat, it is easy to drown. For those able to ride the wave of technology, stay on its surfboard, and see ahead, the force of the wave takes them to the emerging world.

A change in the way we see can bring about a change in the way we think. The helix models transformation, evolving in a spiraling path, stirring its content. It is balanced by a border and an open center. Pattern and the unpredictable coexist. The helix begins the shift to the new with mixing and cross connections. As change accelerates, imagine the torsion of its twist opening and spraying elements in all directions. Out of spiraling change bursts the network.

SEE what you think.

Double helix of DNA

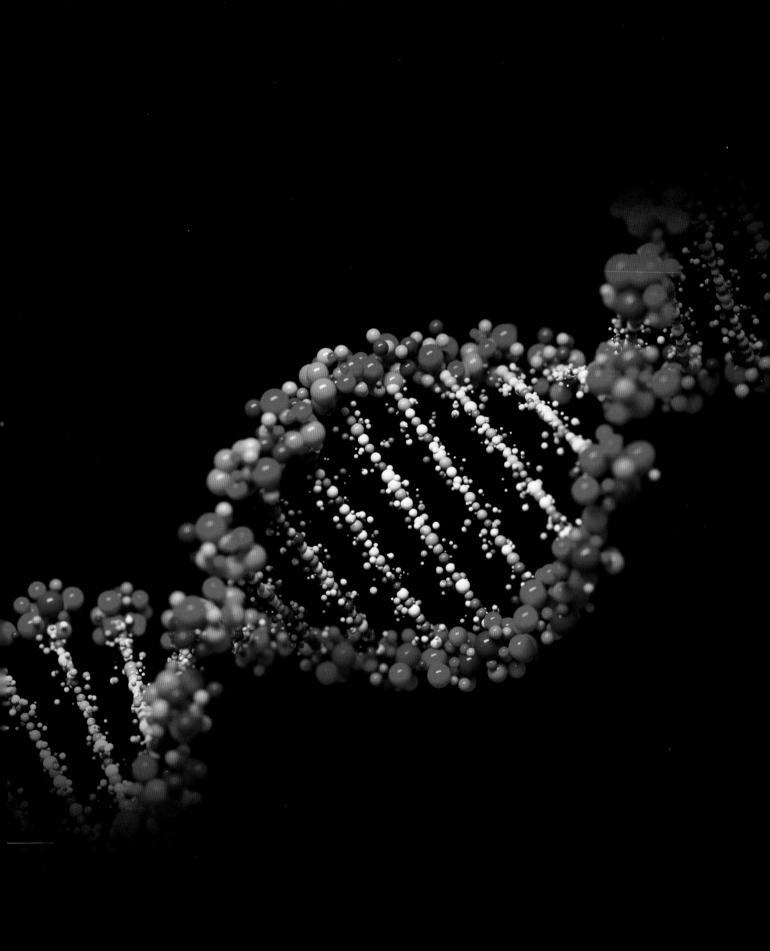

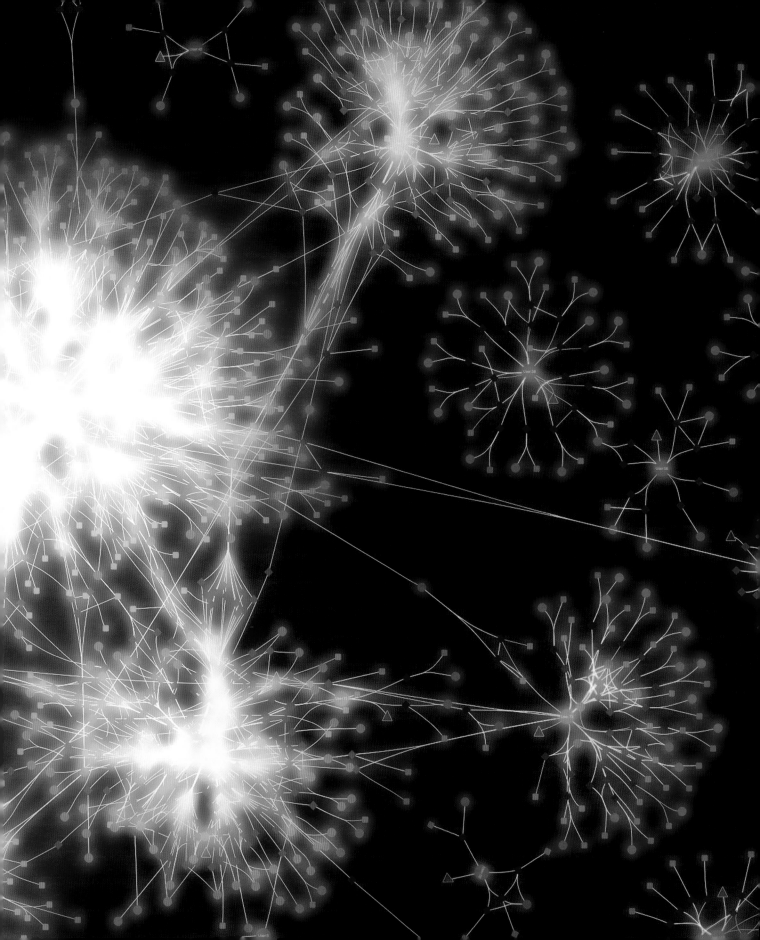

When we try to pick out anything by itself, we find it hitched to everything else in the Universe.

—*John Muir*

The Network

Everything Connects

Classical music is often associated with the world of a past era. But the Internet was the host of the You-Tube Symphony Orchestra, consisting of 101 musicians from thirty countries. Auditions for the orchestra were uploaded from around the world—a harpist from a village in Italy, a violinist from Chernobyl who moved to Argentina and practiced his technique by watching old Jascha Heifetz videos. Judges chose finalists, and the YouTube community voted on the winners. Michael Tilson Thomas, of the London Symphony Orchestra, conducted the first concert of this globally amassed symphony at Carnegie Hall in New York City in 2009. When the symphony played in the Sydney Opera House in Australia in 2011, its live stream reached an audience of over thirty million on computers and another 2.7 million on mobile devices. This orchestra leaves a digital record of the moment on YouTube, though the ensemble is ephemeral, because the musicians return to their home countries. The Internet brought us a new world. It also helped revive an old world, weave a global community, stretch fixed notions of how to audition, how to be selected, how to improvise music via uplinks. Networks allowed an old art form to burst open with new ingredients, new opportunity, and new blends of instruments and cultures.

Computers are the change agent that enabled networks. Their capacity for massive calculations arose thanks to the ladder mindset's emphasis on the quantitative. Zeros and ones drive the system. The internal

circuit board reflects the grid of industrial societies, looking like downtown streets and factory layouts. This quantitative ability brought forth the Internet and catapulted us toward a new era of connectivity, defined by direct contact worldwide, open access to information, and dense social exchange.

Networks are wild with interconnections, reverberations, and possibilities. They support linkages and relationships like the web, but the web was flat. Networks are multidimensional, extending in all directions. Power is contained in its many hubs, not the concentrated authority at the top of a ladder. The more links to a hub, the more influence it has on the network. And yet, a hub can disappear completely, and the system will survive. Networks are dynamic like a helix, yet they explode into uneven, irregular shapes and unexpected links, not contained by helical sides. Pattern and the unpredictable are also at play in a network. Through networks we relearn globally what early humans knew locally: A vibration anywhere is felt everywhere.

Networks encourage us to think in terms of relationships between multiple moving parts. The Internet's capabilities upended commerce, displacing stores, taxis, hotels, and shifted science to look at many simultaneous causes and consequences in ecological, financial, or health fields. From economics to biology, politics to proteins, sales to viruses, outcomes are no longer fixed. We rely on the Internet as our answer for everything—information, shopping, socializing, banking—but when the Internet first began, we did not know how indispensable it would become to our daily lives.

The Newseum in Washington, DC, exhibits a napkin with the first initial drawing of the Internet. It was designed in response to the Department of Defense call for proposals to solve how communication could continue if our nation's capital were destroyed. In the illustration, four West Coast universities connect in simple lines forming the first network. What began as a contract from the Defense Department, that flagship of ladder order, unfolded as a new template of open interaction.

Microchip;
Napkin drawing of
the Internet, 1969

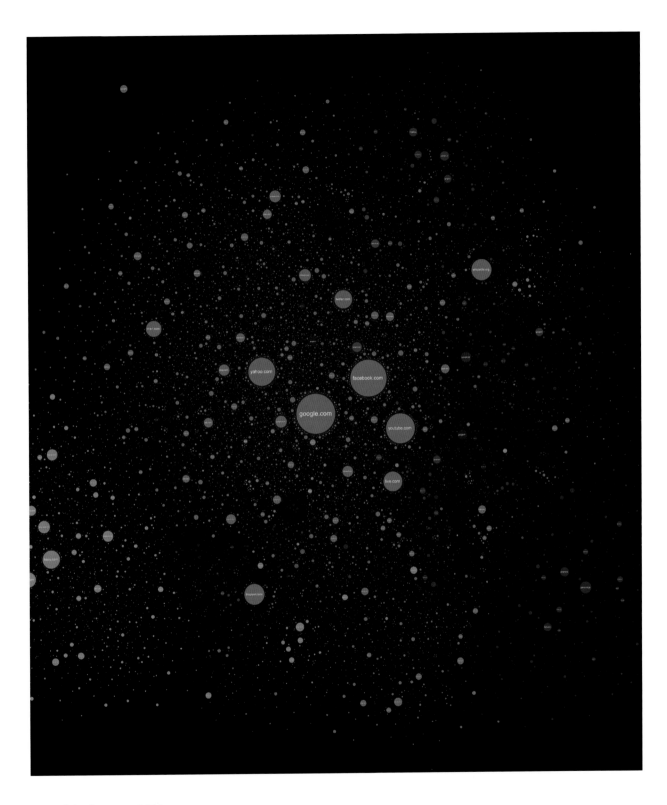

Map of the Internet, 2011

New technology changes the shape of our thinking. Within a few decades the original map of four connections grew into the map where one website uploads to the cloud and downloads to the world. Now an illustration of the Internet looks more like a model of the big bang, exploding in all dimensions. By the turn to the twenty-first century, the Internet transformed our lives. We became so connected so quickly, and with such reliance on our computers, that we feared Y2K, the moment when 1999 turned to 2000, might shut down functions worldwide, cause planes to crash, and wipe out financial records.

For the first time in history, everyone with an Internet connection can be both a broadcaster and receiver, an active agent or an audience. It is not simply one-on-one contact between two people anywhere. It can be one to all and all to one. An active growing hub resembles a *starburst*, a single point with many rays. Every node holds the potential to become a starburst and spawn other hubs.

The consequences and variations of this connective capacity are endless. Political uprisings are triggered by tweets. Cell phones replace bank tellers. Medical advice comes to us from mobile devices instead of doctor visits. College degrees are earned online. Crowdsourcing and social media democratize funding and information flow.

Hyperlinks reflect our newly associative way of thinking. A single Google search gives us historical background, versions of a story, overlapping areas of study, and wider context for whatever subject was entered. We learn by exploring around the subject and seeing its connections. Unlike the linear lines of traditional dictionaries, word definitions appear in an online thesaurus formatted as a network, with common meanings near the center and related meanings in a surrounding burst. Word maps summarize books, ideas, and discussions. Network thinking represents a fundamental shift in ways of knowing and learning, from bottom-line absolutes to contextual thinking.

The Internet has upended education. The term MOOC, Massive Open Online Courses, was coined in 2008. Three years later, Stanford University offered a course on artificial intelligence with 160,000 enrollees worldwide. The online landscape continues to develop with for-profit and nonprofit courses, from major universities and an assortment of entities. Knowledge, certifications, enrichment, and formal degrees now come in many varieties and are available globally.

One to all and
all to one

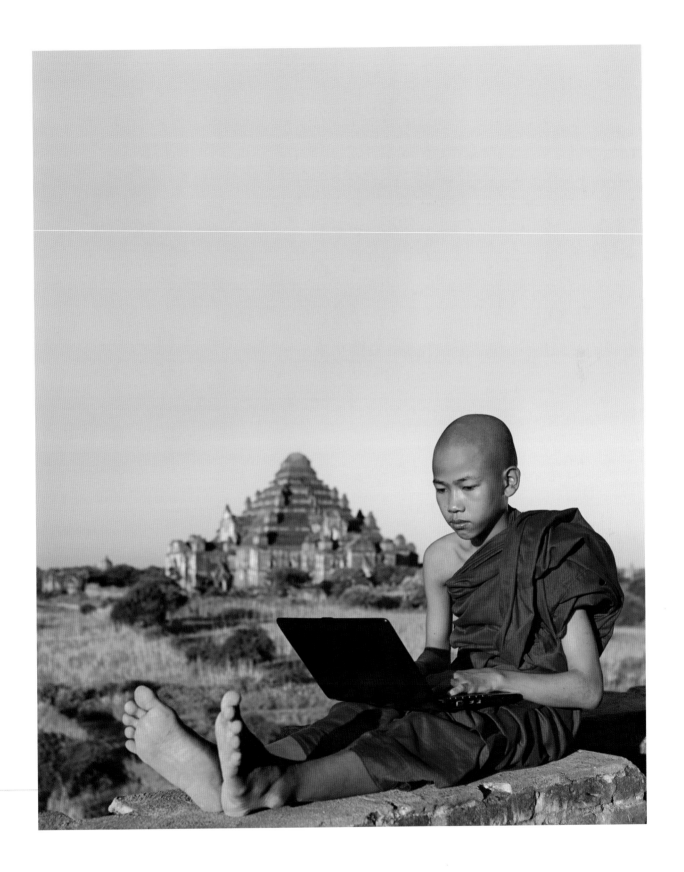

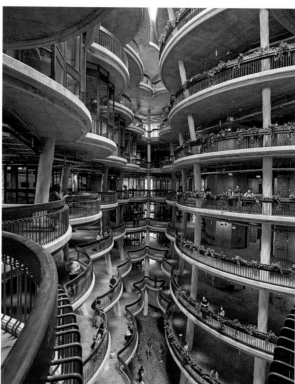

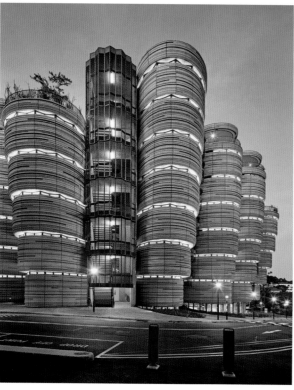

Network Living

New ways of learning are architecturally expressed in the Learning Hub at Singapore's Nanyang Technological University. Twelve curving towers cluster around a scalloped central atrium. On the interior railing of the atrium, you can see people on all floors. Inside, cornerless classrooms encourage collaboration, with no front or back—no hierarchy. Professor podiums disappear, discussion replaces didactic instruction; walkways and sightlines are designed for student connection. The cluster of circular buildings and round classrooms fosters network interactions of humans and of ideas.

The UK Pavilion for the Shanghai 2010 World Expo is a network of fiber optic rods, acting like hair ends that form the undulating outline of the building. The rods transport light from the outside during the day; they glow from the inside at night; and they move with the wind. Standing inside you experience changing light from passing clouds and birds. Light filaments allow visitors to sense how the wind is shifting, how the light alters—as if erasing the border between interior and sky.

The UK Pavilion for the Milan 2015 Expo simulated a beehive. The visitor experienced the hum and stir of an actual beehive via embedded lights and sounds. Bees are the pollinators of nature, just as the Internet is a pollinating system of ideas and communication. In our densely populated cities, we feel as if we are in the stir of a beehive, with the commotion of people, traffic, and noise.

At Singapore's Gardens by the Bay, eighteen supertrees form a grove of tree-shaped structures that contain plants, give shade, harness solar power, and store rainwater for irrigation. At night, they become a colorful light show. Each tree can be thought of as a network in its own right and as a starburst in a grand network.

Hudson Yards will be the largest real estate project in New York City since Rockefeller Center. The centerpoint of this development will be a structure called "The Vessel," a network of interconnecting stairs and landings. The village square becomes the vertical network.

Public squares in front of pyramids once served as trading centers. Bazaars and souks, downtown and suburban stores, required face-to-face interaction. Amazon is now the largest retailer, replacing the handshake with a mouse click. Even the grocery store has been rendered obsolete for some: Using the Internet, you can order a prepared dinner or fresh ingredients for a week, delivered straight to your front door.

Data is displayed in network formations that reveal pattern and relationships. By seeing how links and nodes aggregate, you can quickly read

Top: Exterior and Interior, "The Vessel," Hudson Yards, New York City, design 2016

Bottom: Exterior and Interior, "Learning Hub," Nanyang Technological University, 2015

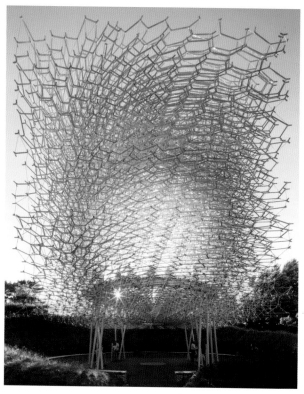

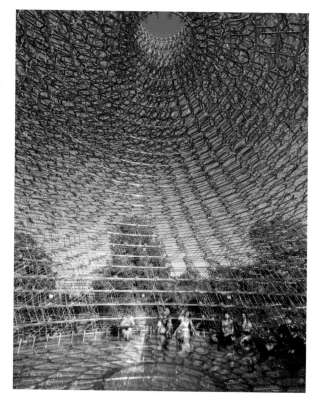

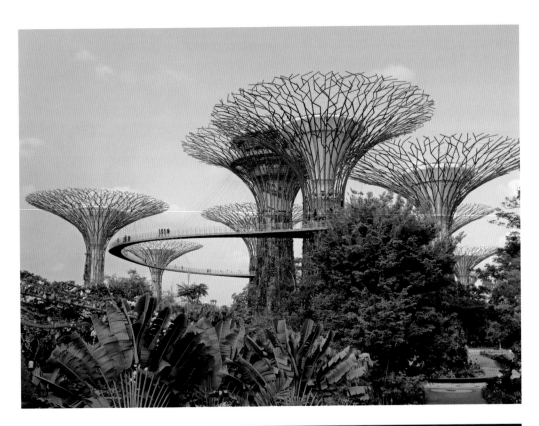

◀

Top:
"Seed Cathedral,"
UK Pavilion,
Shanghai World
Expo, 2010

Bottom:
"The Hive,"
UK Pavilion,
Milan World
Expo, 2015

▶

Supertree
Grove, Gardens
by the Bay,
Singapore, 2012

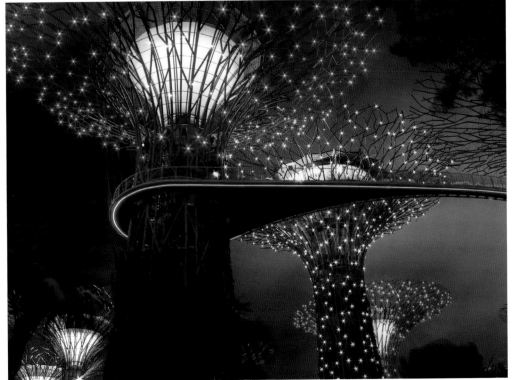

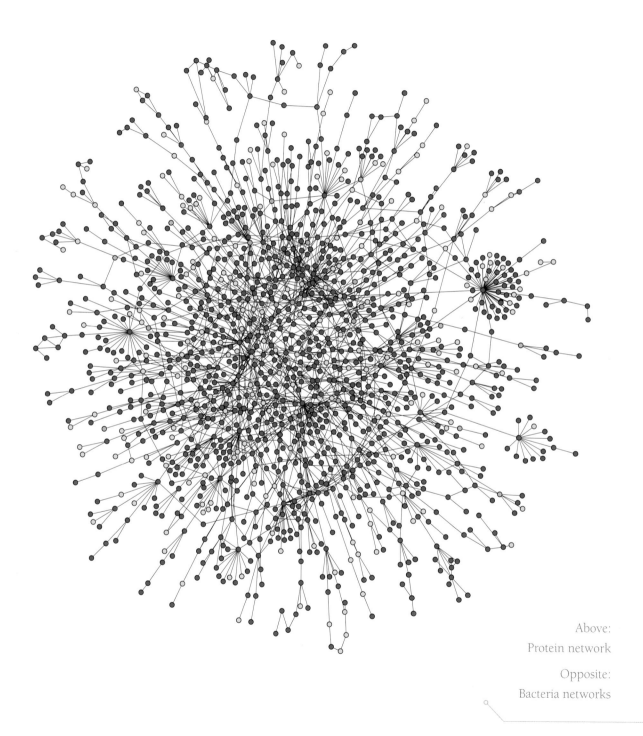

Above:
Protein network

Opposite:
Bacteria networks

viruses. In computer networks, the spread can be far-reaching and instantaneous. The virtues of a network system are also its vulnerabilities. The more connections we make, the more risks we take. We don't know the full equation of what is lost and what is gained in this new world. The Internet fascinates and distracts; it isolates and creates communities without face-to-face experience; it expands minds in both fantasy and facts, confusing real and virtual. What we do know is that hyperlink thinking is the new norm. Thinking is an associative process; hyperlinks multiply our awareness. Networks are our current frame of mind.

Enlarge Your Lens

Networks burst with infinite filaments. They have many centers, not the single hub of a web, not the central open core of a helix. Networks are resilient—constantly transitioning, learning, and adapting. They open us to a participatory world, where every node holds new potential. We may view the network as our current shape—our answer to everything—but we must not forget that the dominant shape of an era is in motion over time.

Economic exchanges in early cultures were about sharing and bartering. Unessential possessions were extra baggage in migratory living. Natural objects such as shells, obsidian, and beaver skins held value for trade. Accumulation and currency entered in the ladder frame of mind. The-more-the-better attitude seeped into cultures based on measurements, with the abundance at the top of the pyramid attainable only by a few. Now one-on-one exchange becomes possible again, through the Internet. eBay is much like web-era bartering, made possible through ladder technology. Humans have gone from valuing sharing to accumulation to sustainability.

Early humans wrote in pictographs, images on a wall that all could understand without the need for literacy. When the alphabet entered, text could be read only by the educated, a severe separation between the literate and illiterate. Now icons return to symbolize ideas and speed

Earnings
Trillions of Dollars

Barter shells; Accumulation;
Sharing Economy

Pictograph; Linear Text;
Icon + Text

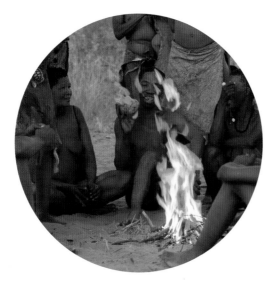

Rotating leadership;
Hero as leader;
Open source participation

navigation on cell phones and software. Images return as the dominant form of communication.

Leadership positions have not always been filled by a single person. Hunting and gathering required cooperation to corner, kill, and distribute the food. Often the one who made the kill by harpoon or arrowhead was the last to partake of the spoils. Social harmony, not heroics, was the goal. Leadership in the ladder's hierarchical mindset is embodied by a male hero on a white horse, the commander of men, who sets the course and expects others to follow. Now, in a participatory, open-access world, from Kickstarter to open source software, we each can play an important role in influencing outcomes.

As shapes of thinking shifted over eras, political systems transitioned from bands and tribes to nation states. Now identities form around causes rather than countries. Ecological views change from seeing nature as a sacred circle in web living, to viewing nature as the resource for consumption in a ladder mindset, and now return through principles of sustainability. Social systems shifted from interdependence to hierarchy and now are networks. Justice in early societies centered around reconciliation, then switched to retribution within the ladder mentality. Now, mediation and conflict resolution are beginning to gain traction. Migratory bands and tribes made decisions through councils and consensus; authority rested in the center. Top-down decisions served ladder efficiency. Politics, commerce, and ideas now thrive in robust hubs of a network. Anyone with a smartphone can tweet the pope, the president, celebrities, and CEOs. Communication intensifies in a participatory world.

When the Internet first began, people thought it would be used mostly by academics sharing their research papers. In a few short years, it upended everything from commerce to communication and reinvented institutions as diverse as health care, warfare, and education. Now, smartphones deliver entertainment, education, and medical advice; store data and images; transact payments; and evolve with every new app. Drones deliver goods and medicines without waiting for roads and runways to be built. A ratchet wrench was 3-D printed on the International Space Station following a blueprint uploaded from Earth. Virtual reality is beginning to expand our imagination. These dazzling new worlds ease life for many but will also displace large numbers of others no longer able to get a job or be digitally literate.

Technology leaps displace jobs and the very meaning of work. Nearly fifty percent of current jobs will be replaced in two decades. Robots assist in surgery, stock warehouses, and drones deliver packages. Computers scan

CHAPTER 6

The Lens Enlarges

Macro and Micro Views

> We cannot solve our problems with the same level of thinking that created them.
>
> —*Albert Einstein*

In 2011, I visited the Roman Temple of Bel in Palmyra, Syria, a city buried in sand for thousands of years. At the site, an archaeologist described how builders placed cushioning material between the stones of the temple walls in anticipation of an earthquake every century or so. The builders planned for this temple to exist through millennia. And it did. But no longer. ISIS destroyed the temple in 2015. One group's assumptions of truth could not tolerate another's, even if it was only in the form of a roofless perimeter of stones built two thousand years earlier. When the temple fell, a collective cry of loss echoed around the globe. A pride in ancient civilizations' accomplishments, in their art and engineering, was a universal pride in human imagination, not as followers of a religion, but as members of a species capable of creating wonders.

While it is foolish to assume we can predict the future, it is more foolish not to try to anticipate it. The future can pivot in many directions. Now, the cushions needed to plan for the future may not be flexible materials, like those buffering Palmyra's temple stones. They may be flexibility in points of view. Enlarging our lens, seeing with the widest view—in time, in directions, in options, in consequences—can help us anticipate what is coming next.

We are at a point of breakdown or breakthrough. We can fall into a narrow, single-minded idea that

imposes itself on complexity. Or we can widen our view, embracing diversity and uncertainty, as we map new frameworks of reality.

The enlarged view of Earth from space reveals nature in constant change: whirling weather patterns, circulating ocean currents, a wild diversity of life. Yet with all that motion and commotion, nature's ecosystems balance, sustain, thrive, and evolve. Pattern and the unpredictable partner in the mindset of the next.

Temple of Bel, Palmyra, 32 AD

Seeing from Space

One night as a teen, I walked along a Texas coastline. The moon's beam reflected in the water in a direct line to me. The beam moved as I moved, following me along the shore. A peculiarity of physics and perceptions perhaps, but my youthful mind felt a personal connection to the moon, the same as early humans must have felt. The moon was my companion, not an object in space.

For ages, humans looked up at the heavens to view its beauty and wonder about our place in the vastness. But the ability to observe Earth from orbiting spacecraft and satellites emerged only in the last several decades. The space program developed as a culmination of ladder power: linear thinking, precise measurements, and finite goals. The ladder mindset helped make the rockets that propelled us off Earth. Ladder competition with Russia's Sputnik hastened the US space efforts. When President Kennedy set the task of landing on the moon, the gathering of technicians, mathematicians, and engineers was as dense at NASA as it must have been around the construction of the first massive pyramids.

Thanks to ladder technology, astronauts have walked on the moon, experienced the bounce of its low gravity and the depth of its powdery surface, seen up close its meteor-made round craters, and collected its rocks. The magic of the glowing white ball is not lost, but the focus is now the particularities of the moon's physical properties. Our lens shifts from seeing

Astronaut floating in space

"We thought we were exploring the moon
but we discovered the Earth for the first time."

the moon from a distance to zooming in to walk on its bumpy surface—from mystique to measurement.

The gift of the venture to the moon was looking at Earth from space and seeing it as beautiful, fragile, and whole. To astronauts peering out the space capsule window, the feeling of magic returned. Earth glowed as a shining blue planet, as small as the white ball of the moon looks to us on Earth. When the image first appeared, it was as if a voice announced over a loudspeaker: *Ladies and Gentlemen, we are floating in space*. Planet-centered consciousness was seeded. We saw Earth as a whole for the first time. A thousand years from now, humans might consider this first step off our planet a moment as pivotal as when the first creature emerged from water to walk on land, or when the first ape stood and walked on two feet.

"Once a photograph of the Earth, taken from outside the Earth is available . . . a new idea as powerful as any in history will be let loose."
—FRED HOYLE, COSMOLOGIST

From space, our planet appears as a single organism, a dot in a vast expanse. Parts unify into wholes. Our most common assumptions are upended as a new scale of understanding emerges. To an astronaut's eye, national borders do not exist. The sun is no longer a meter for sleeping and waking. In orbit, there are sixteen sunsets in twenty-four hours. In the vast blackness, no compass orients east and west. There is no gravity to declare top and bottom. Earth and sky are in the same window frame, no longer severed. It is Earth, not the moon, which rises in the curved horizon, and unfolds from crescent to full sphere. We transcend separation—of time, of space, of nations.

Planetary consciousness needs a mindset as expansive as the view. We begin to see how interrelated we are. Our daily headlines are about global systems—the Internet, viruses, financial interdependencies, ecological interactions. Fires in the Amazon pollute the air in Arizona. Volcanoes in Iceland halt air traffic on all continents. Melting Arctic ice raises ocean levels on all coastlines. Global reverberations apply to disease or propaganda, bank loans or riverbanks, knowledge or terrorism. Ebola, Asian flu,

Data from
global sensors

parasites from Central America find their way across borders and continents. Dividing lines disappear.

Nature's rhythm does not change. Our perception changes. We enlarge our lens to a wider reality. As we begin to see ourselves as part of a spinning sphere, protected by a thin skin of oxygen, we awaken to a common identity, trumping any illusion that we are separate from nature or separate from each other.

Fern leaves and
Broccoli florets

"We went to the moon as technicians,
we return as humanitarians."

—EDGAR MITCHELL, ASTRONAUT

From Parts to Patterns

From space, patterns pop out. What looks like the silhouette of a tree is a river delta; what looks like a river delta is an image of the veins in a leaf.

Globular forms that appear in satellite images of a lake in Western Australia are similar to microscopic images of a West Nile virus. Satellite pictures of a river delta in South Yemen echo the bronchial pathways in our lungs. Consistency of design exists at every scale. As above, so below. From the macro lens of space to the micro lens of images inside our body, repeating patterns give us clues to creation.

Fractal parts mirror the whole. The leaflet of a fern is the same shape as the fern. A broccoli floret is the same shape as the head of a broccoli. The world is replete with designs repeated at every scale that we are just beginning to discern. Symmetries at all scales of nature comfort us in their repeating design. But understanding nature is not that simple. Repetition is not exact replication. Unique variations surface in genes, and in seasons arriving early or late, wet or dry. To anticipate our future requires allowing for uncertainties. Patterns do not mean predictability. Gravity on Earth does not extend to space. Reality at quantum levels flips all our assumptions of how matter behaves, leaving us guessing about whether something

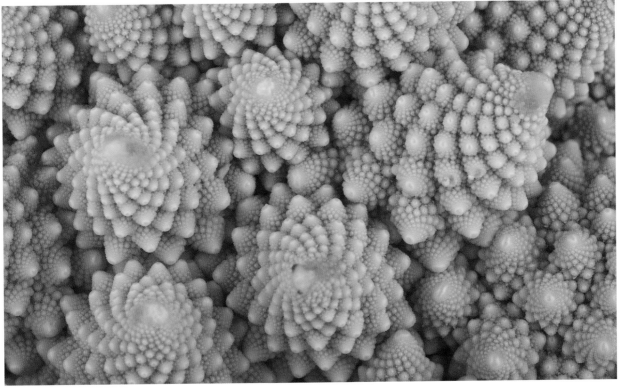

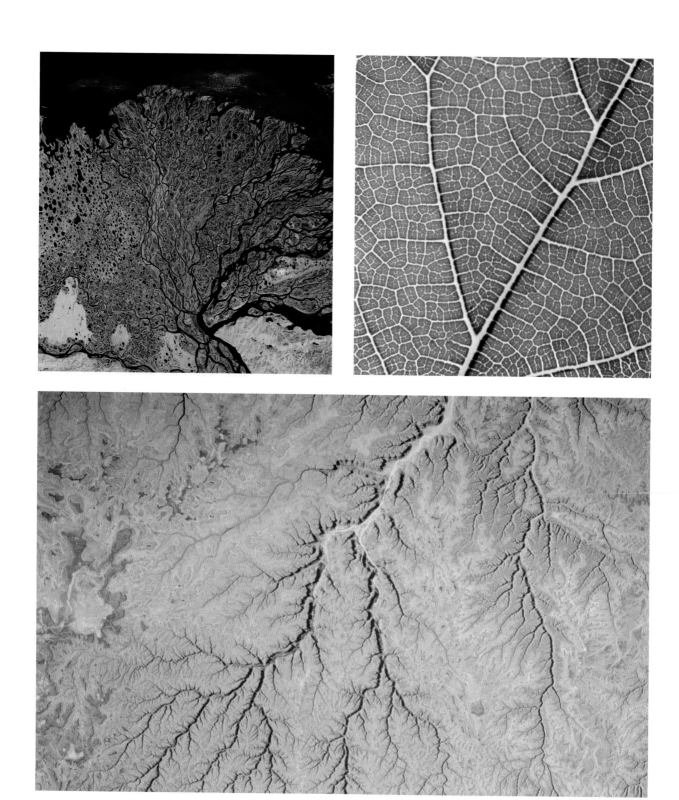

River delta, Veins of a leaf, and River beds

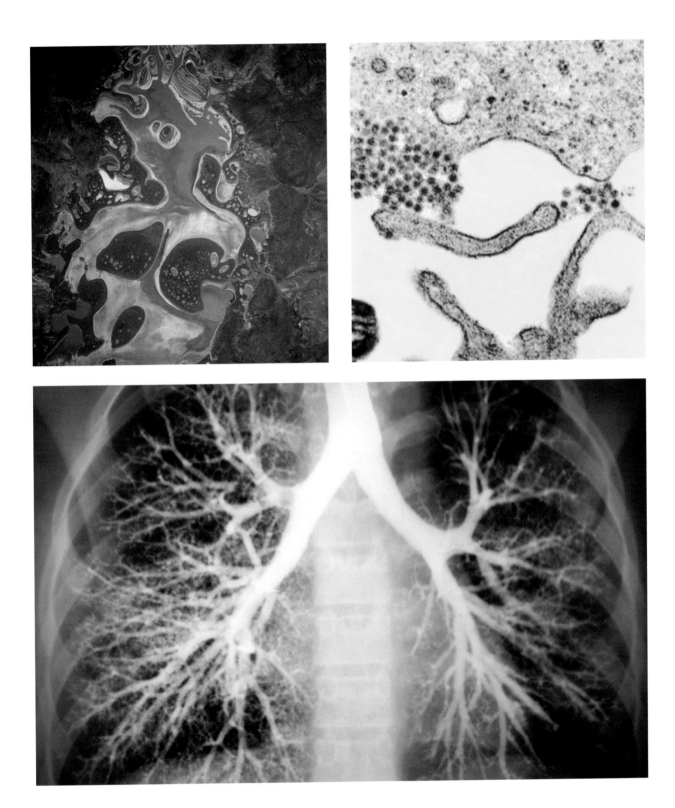

Satellite image of lake, Microscopic image of West Nile virus, and Bronchial tubes

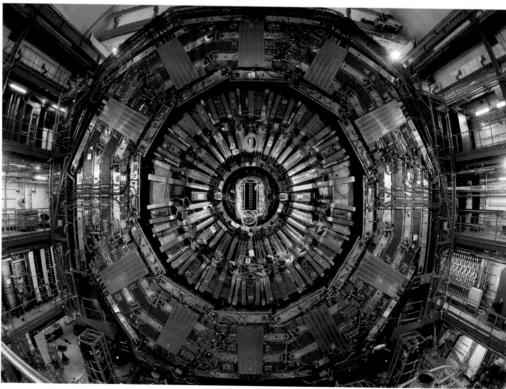

Astronaut working
on the International
Space Station

The Large Hadron
Collider, CERN,
Switzerland, 2008

is a particle or a wave, and doubting whether we can observe particles without changing their behavior.

Looking for essential truths and deeper patterns, two major enterprises are exploring realities at the macro and micro level—the International Space Station and the Large Hadron Collider, built by the European Organization for Nuclear Research, CERN.

The space station widens our lens to view global weather patterns, spreading deserts, and changing coastlines. Men and women from Canada and Kazakhstan, Sweden and Spain, Malaysia and Denmark, to name a few, have flown on the space station. The crew on board the International Space Station relies on each other with the interdependency common in early human bands. As humans explore space, an opportunity arises to create a new vision of mutuality, of agreements and common enterprises that supersede national interests and lead us to cooperation. All humans on Earth share a common fate, depending on how we use or abuse water sources, the air, and ultimately human relationships.

Inside the Earth, the Large Hadron Collider, a seventeen-mile ring, was built beneath the French and Swiss border for experiments in particle physics. Over ten thousand scientists from about one hundred countries participate, both allies and enemies. Physicists from Iran and Israel work together to address fundamental questions about the origins of the cosmos, their inquiry superseding national disputes. The Large Hadron Collider data analysis team contains its own international community, using 170 computing facilities from thirty-six countries. The Hadron Collider is the world's biggest machine, exploring our smallest particles, to construct our latest best guess of how reality works.

"Something deeply hidden had to be behind things."

—ALBERT EINSTEIN, REMEMBERING SEEING A
MAGNETIC COMPASS NEEDLE POINT NORTH AT AGE 4

New technology enlarges our lens, giving us fresh eyes for things large and small, capturing motions that occurred overnight or over millennia. Images that expand our idea of reality are coming to us on all scales—from

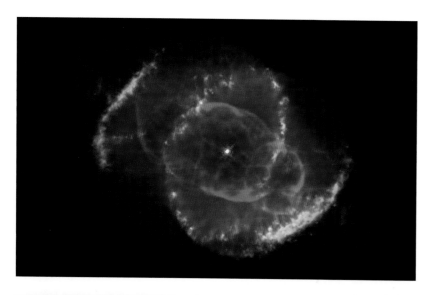

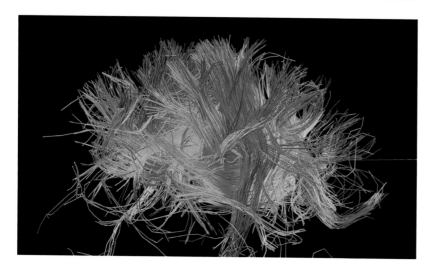

Cat's Eye Nebula;
Seismic imaging of Earth's geology;
Diffusion MRI of brain

inside the cosmos, the Earth, and the human brain. The Hubble telescope shows dust and gases swirling into cloud-shaped nebulae. Seismic sensors picture information from inside Earth's geologic layers rubbing against each other over time. Diffusion magnetic resonance imaging machines trace activity inside the brain. The more familiar we become with images at macro and micro scales, the more we learn about the connections in process and patterns. The atoms in our bodies were birthed in the caldron of the stars. We are not simply a part of the larger whole; traces of the whole are in us.

"My atoms came from those stars . . . there's a level of connectivity . . . we are a participant in these activities . . . just by being alive."
—NEIL DEGRASSE TYSON, COSMOLOGIST

The old adage says you cannot see the forest for the trees. But with new technology we can see the forest *and* the trees. A laser-scanning LIDAR device flying over Panama's rain forest can discern the species of an individual tree, its shape, its chemical composition, and its health. This same device visualizes the topography of the Tambopata River system in Peru, revealing ancient river channels, showing the current river's location, and forecasting where it will flow next. Seeing the river's history, we can anticipate its future. New sensors predict drought, measure water in aquifers, snowpacks on mountaintops, and detect how fast certain lands are sinking. This new information can diagnose the ecosystem, alerting us to what is next.

With expanding ways to image, we need to keep in mind that we are seeing the shape technology brings. It may or may not be a full or accurate image of nature. Pictures of the universe and the cells in our brain reveal similar patterns, with tissue-like fabric connecting lines and synaptic points. But we must remember that the image is our imposition. Data from sensors compiles the picture, but the picture is incomplete, since there is so much we do not know how to sense in the vastness of space. Current images may not be a clear representation of a larger reality of which we are unaware, cannot record in sensors, cannot yet imagine. Like the grid of

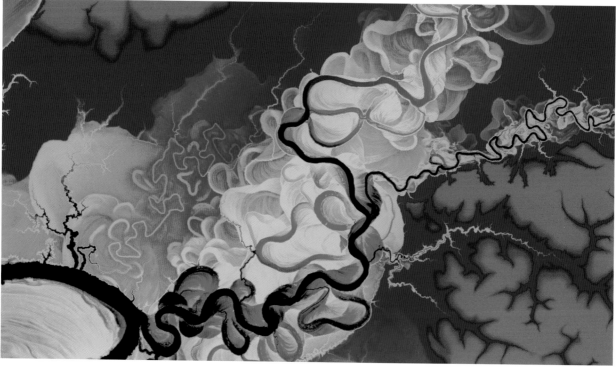

LIDAR radar scan of rain forest, Panama; LIDAR radar topology scan of river
basins revealing past river beds, Tambopata, Peru

Visualizations of the universe and the brain

way to discern pattern in the midst of information overload, in the chaos of escalating change. The new patterns are dynamic systems, not fixed references. They require eyes alert to all dimensions, presuming visible and invisible realms, not holding tightly to former expectations, older frameworks. We are being forced to reinvent social and political structures that will sustain us. As we enlarge our point of reference—from seen to unseen, local to global, real to virtual—the structures that bind us will also enlarge.

Shaping the Future

To hold our new perceptions of a world in dynamic motion, we search for a shape, a model containing multiple points of view, a framework allowing for opposite truths—a new mindset. The web era was defined by a recurring circle—a mental map made of sunrises and sunsets. The ladder era had a beginning, a middle, and an end, a story defined by gods and kings. The helix and network are open-ended. Our story of life now comes from the helical braid of genes. Our daily lives link in network connections. In the space age, we start to see self-similar patterns at all scales. We do not know what shape, what mindset will dominate next, but we can speculate by studying emerging science, architecture, art, and technology.

One possibility is a torus—a doughnut shape. It is the shape of the magnetic field around humans and the magnetic field around the Earth. It is also the shape of apples and oranges, with their round sides and open inner core. The shape appears in smoke rings, ocean systems, atoms, seeds, and the magnetic field around planets, stars, and galaxies. Some theoretical astrophysicists model multiple universes as a stack of torus systems.

Picture a spinning torus, where movement flows out from the center, curves, and enfolds back around the other side. Imagine yourself on the top of the doughnut moving outward, away from the opening; you would see an expanding universe. Then imagine yourself on the outside edge of the doughnut folding back under into the opposite end of the opening; you would see a contracting universe. A spinning torus both pushes out and draws in. At first it appears opposite, yet as a whole it is balanced and self-regulating. The torus combines elements of earlier shapes—circular, spinning, interconnected, and in flow.

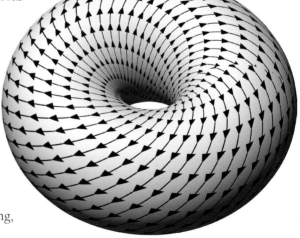

Torus shapes

Top: Model of stacked universes. Shape of apple.

Bottom: Magnetic field around human body and around Earth

Guangzhou Circle,
China, 2013

Florida Polytechnic
University, 2014

Huzhou Sheraton
Hot Spring Resort,
China, 2013

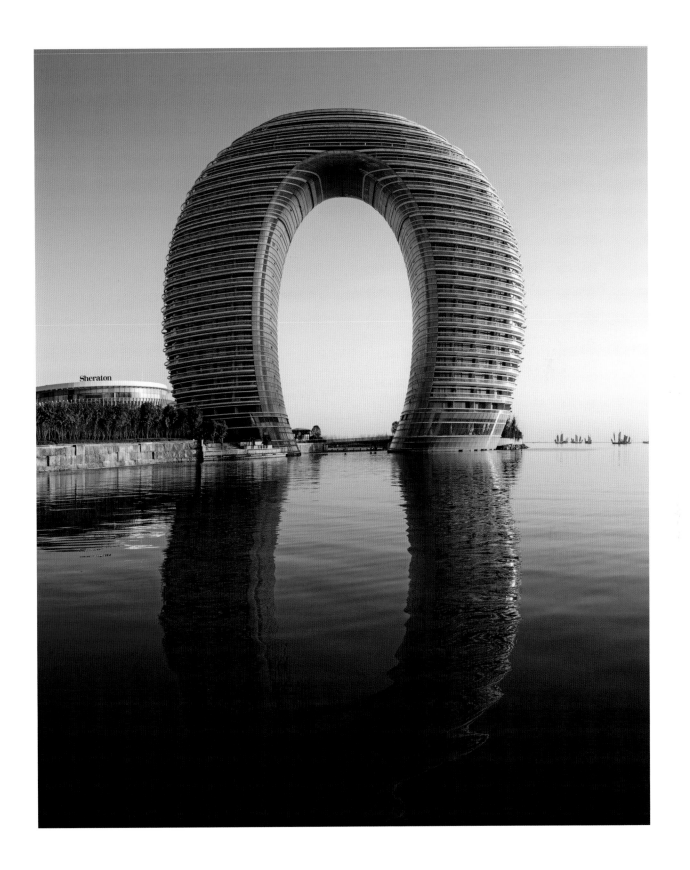

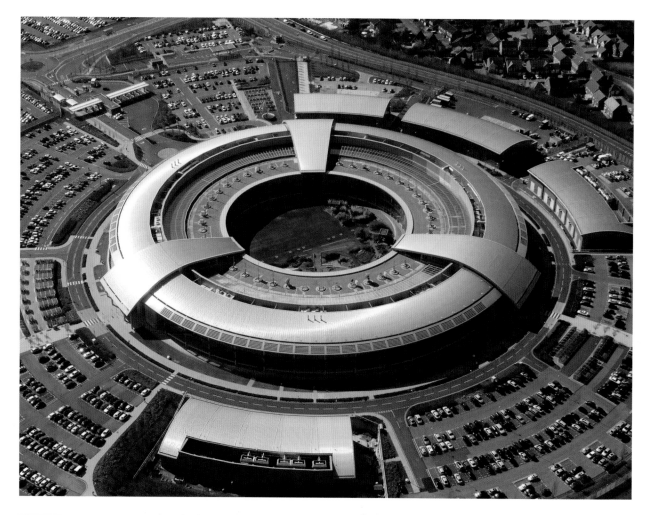

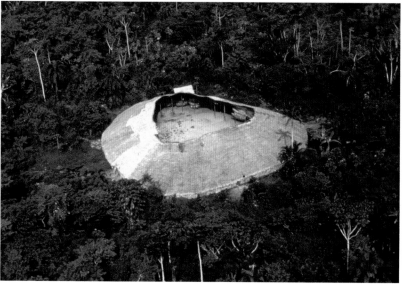

The web's circle returns:
Government Communication
Headquarters (GCHQ), Cheltenham,
Gloucestarshire, UK, 2004

The communal house
of the Yanomami, Brazil

follow straight lines, assuming there is one answer, and we arrive at our destination by not straying. From "rectangle" we are reminded of the word "rectitude"—a world of rules. For centuries, we spoke of the four corners of the world, even when humans knew our planet was a sphere. Within a torus, lines and corners disappear. A torus encourages us to look in all directions, to see the same thing from different angles. A spinning torus shows how the inner and outer are not separate but part of a flowing whole.

"The opposite of one profound truth may very well be another profound truth."

—NEILS BOHR, PHYSICIST

With the speed of change, we feel unmoored from old assumptions, as afloat as the astronauts are in space. By expanding our point of view, we see that old assumptions may still work but do not apply to all scales. A carpenter's level gives us a straight line in our homes, even as we live on a spherical Earth. Gravity holds us to the earth, even as we are weightless in space. Things can be true in their context, even if it means that sometimes opposites can each be true.

We reshape reality by era, culture, and symbol. Early humans lived according to the constants of nature and common purpose of the group. Now accelerated change in technology, mobility in living, and fusions of cultures require constant adaptation and adjustments. There is no resting spot in professions, because technology requires continuous retooling of skills. There is no permanent answer to where we may live in the future, because economics, wars, and family needs bring unexpected crises. There is no single simple solution to problems as complex as climate change or trade agreements.

Living in new shapes, reshapes our thinking.

The torus mindset is dynamic, in motion, full of opposites, though the curve of its flow actually brings it back in balance. The ring shape of a torus looks elegant, yet it can be turbulent and wild in its spin. Things swirl, uproot, and are in a perpetual stir. The overall forces hold feedback loops that resolve and self-regulate, though the process can

We have been accustomed to a format of duality, and with two resolving in a new third entity. Now we are aware of complexities too large for familiar boxes. Images and data come from inside particles through accelerators, from inside our bodies through an electron microscope and MRI, and from nebulae at the edge of observable space through Hubble and probes launched from Earth. We are only beginning to put together the data in fresh patterns. A larger mindset is needed that scans for more possibilities, creates multiple solutions, enlarges our worldview, challenges our presumed maps. We should be awake to and aware of the shifts in all directions, ready not only to impose plan A or B but to invent options A to Z, alert to opportunities and improvisation.

The Lens Enlarges

Counting and math had to be conceived. Writing had to be invented. We don't yet know what the next big thing is that will give us glimpses of hidden patterns as math does or give us ways to record and share those ideas as writing does. We are just beginning to discern the electromagnetic and gravitational waves in deep space. Early technologies of writing and farming led humans to feel in control of nature. Current technologies take us into infinitely larger and infinitely smaller space where all becomes uncertain. Laws of nature we have accepted for hundreds of years seem to be broken or no longer apply. At the quantum level, particles and waves interchange. Ninety-five percent of the perceivable world is labeled dark matter and dark energy; we don't know what it is. We can discern only five percent.

In science, Galileo flipped our view of the Earth's position in the cosmos, a position we are still enlarging in space probes. Newton gave us an understanding of gravity, yet his approach locked us into a mechanistic view of the world. Einstein and Heisenberg were at first considered crazy and then wrong about their theories of relativity and uncertainty. And someday these theories will be overturned. The lens enlarges, giving us more clues, leading us to different guesses, but making it very clear these are temporary toeholds.

In social matters, humans progressed from bands to tribes to nation states. Now identity can come from supranational causes, such as Greenpeace or ISIS. Bitcoins are currency without a country. The idea of the

Nature returns in
green architecture

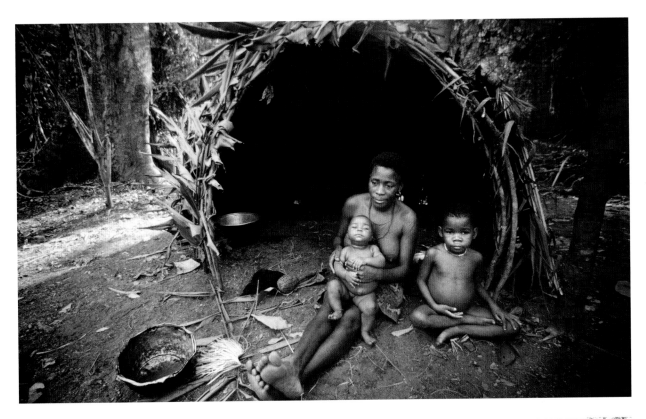

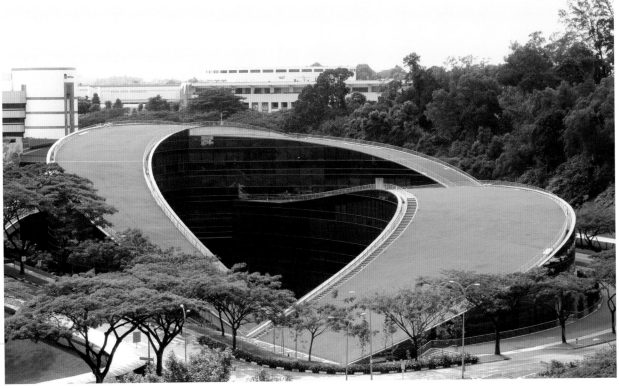

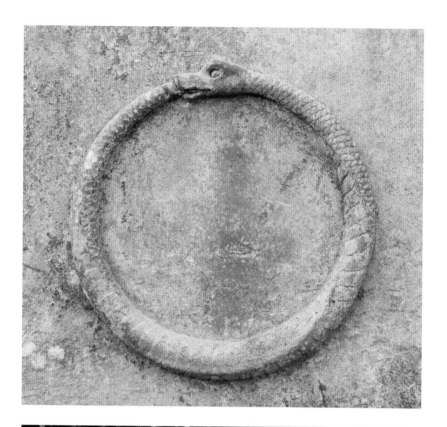

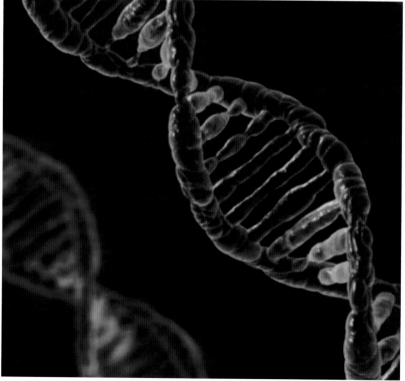

Story of life, death, rebirth
returns in DNA

family unit stretches to blended stepfamilies, same sex parents, and males as the lead caregiver. New patterns of living are continuously evolving.

In technology, disruptions come daily, sometimes taking down whole industries—manufacturing, transportation, retail. Technology also brings beneficial breakthroughs—robotic surgery, stem cells to regrow organs, 3-D printing to scaffold bones, immunotherapy that boosts the body's ability to cure cancer. Boons and busts are both part of the equation, launching forward or being erased by automation. From a ladder point of view, disruptions feel like a win or lose situation. From a network point of view, change brings creativity—new ways to relate, solve problems with a variety of answers, access multiple funding sources, and share computer power for the largest questions of science.

The large concerns of our time, nuclear proliferation and terrorism, do not disappear. But globally it is also true that there is less poverty, fewer deaths from war, and better health indicators worldwide. Worldwide, since 1955, absolute poverty dropped more than half. Deaths caused by war fell from 250 per million people to less than 10 per million since 1950. Life expectancy jumped from forty-seven years to seventy years in the last six decades. A larger view can add optimism.

We need to be aware of beneficial as well as detrimental changes, and we need to keep a wide eye for options without getting stuck in a fixed mindset. In moments of uncertainty, we constrict out of fear instead of widening the view to look for options. The anxiety of our time may be a lens too small.

Accelerated change has a hidden benefit. Patterns surface faster, emerging within years and months rather than centuries and millennia. Data analysis, the foundation of the ladder's measured world, evolves to highlight relationships. Relationships are the payoff that gives us pattern. As we become familiar with the pace and pattern of exponential change, we can project further into the future, giving ourselves a chance to change things, to participate in better outcomes for issues as varied as ocean health, education, clean air, and food supply.

In kindergarten we play the game of same or different, learning how to order, associate, and distinguish. These are lessons we never stop learning: How we apply those lessons, however, expands. Symmetries at macro and micro levels become evident in the similar patterns of lakes and viruses and of hurricanes and galaxies. What is disruptive or cataclysmic at one scale can be thought of as creative on another. A hurricane is disastrous if it demolishes your home; yet in nature's scheme it wipes out the old and

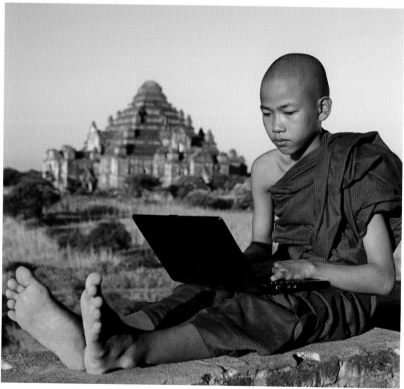

Connectivity returns
in the Internet

allows fresh growth. What seems chaotic resolves into pattern in the context of larger orders. Our fear of chaos can calm when larger orders become apparent. In DNA's helix, we see that repeating patterns and unique expressions coexist. Networks show us that connections as well as fresh outcomes are everywhere. The view from space reveals that there is similarity, but not sameness, at all scales.

"There can be separateness without separation."
—DAVID BOHM, PHYSICIST

An Adaptive Mindset

As our way of living changes, our mindset must adapt to the emerging reality. The shifting is continuous and accelerating in our moment. How we communicate, coalesce, and find identity are constantly in motion. To stay in balance during exponential change requires adaptability, flexibility, and a mind scanning for what's ahead.

Ordinary people may be as talented as experts in projecting what will happen next. A multiyear study by a University of Pennsylvania professor found that certain laypeople predicted future outcomes more accurately than experts. A certain selection of ordinary people—filmmakers, pipe workers, ballroom dancers—outperformed intelligence analysts on predicting the consequences of issues including Venezuelan gas policy, North Korean politics, and Russian intervention in Ukraine. The common core of the "superforecasters'" abilities was an open mind—a mind alert to nuance, seeking new information, and willingness to adjust their earlier conclusions.

Fixed mindsets—versions of history, science, or family lore—can block us from seeing a larger reality. We create narratives out of the information we are bombarded with, but the stories we conjure may lead us to false conclusions. We need the superforecaster's open mind and eyes open to the changing landscape. It is not simply a task of connecting the dots. The

new patterns will be dynamic, multidimensional, relational, and in constant adaptation.

Humans may be more prepared for change than we realized. We have new understanding of how the brain works. In the past, we thought intelligence was fixed, that you could not grow new neurons, and that memories were accurate and unchanging. Now we know the brain is elastic, adaptable. Memory becomes unreliable with the discovery that it inhabits the same part of the brain as imagination. It continuously puts together new stories of what we experience and maps of what we see. The constant change we are trying to adapt to in the world is what the brain has always been doing—weaving stories, drawing maps.

Humans are wired for adaptation. We have extended childhoods. Other animals are hardwired to survive soon after birth. Our brains are ready for experience to imprint according to the physical environment, language, family, and cultural structure. We can only imagine how this adaptation will evolve as we explore space.

Our eyes notice a short spectrum of the electromagnetic range. Our technology reads ultraviolet, infrared, gamma, and radio waves. The sense we make of this data is in our brain. We are the viewfinder and the storyteller of the stimulus and information coming to us. The story we tell about what we download becomes our version of reality. We make it up in latest theories, but it is a moving target, ever corrected, expanded, and reconceived.

Artificial intelligence, cloud computing, robotics, genomics, stem cells, and synthetic biology are transforming our time and our bodies. The digital world and the biological world are merging. Data from the ladder world and nature's design from the web world come together to create a synthetic bacterium. Genetic engineering holds potential to create fuels and food, clean water and vaccines. The uses for this brave new world have benefits and risks. The potential follows human potential—to be beneficial or destructive. Our wisdom needs to keep pace with our technology.

One source of wisdom is a wider lens—looking back at history, understanding complexity and uncertainty as part of the equation, allowing for the unseen and unforeseeable, adapting to new conditions. We have instant information and instant connections that are without wires and without borders. The immediacy that technology delivers changes notions of time and space and identity.

More than half the population of the globe now live in cities. Reverberations are quick and wild; the benefits can spread as rapidly as the dangers. Ideas and events spray out like a starburst, affecting the hearts, minds,

Buildings reflect
beliefs

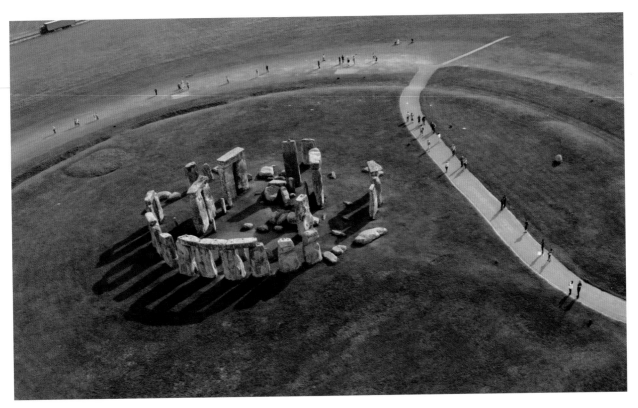

security, and economics of those living far afield. We may be even more tightly woven than early human bands, yet in terms so different we do not realize the full consequences of actions. It is more essential than ever to see the whole, the wider realm that will lead us out of locked divisions.

Shape is a vehicle to understand worldviews of the past and to help us notice emerging ones. We stay locked in a useful mental map until new technology, historic or natural events force us to reframe our version and view. Migratory humans' web world was based on nature's repeating cycles and connections. For the past several millennia, the ladder mindset of the line of progress has directed us to see the world as fixed and conquerable. The helix matches our time of spiraling change, with elements continuously stirring. Networks spur interactions, reverberations, and open access, with no single destination or single truth. Our mental maps now expand to absorb a bigger picture—the view from space, the visible and invisible world, the physical world and the quantum world, the reality of our five senses and the virtual reality of extended senses.

Farming disrupted migratory humans and led to fixed locations, where hierarchal orders were more efficient for larger populations. Measurement escalated from barley trades to computer calculations, rocket science, the Internet, and cloud storage. Each new entry upended a secure view of how the world works and job security for how people work. Cataclysmic changes can lead to revelation or revolution, as economic, social, and scientific orders are overturned. They seem as if a force beyond our control has overwhelmed us. Yet these new realities are created by humans. If we adopt the mindset of creativity, we can continue to adjust to the new and experiment with the next. We created the changes; we can invent the solutions.

The web world existed for hundreds of thousands of years. Agriculture took tens of thousands of years to produce permanent settlements. Ladder thinking intensified over centuries to become industrial societies. The digital world is spiraling to us in decades.

Web thinking returns in new dimensions. The relationship to nature comes back as green architecture in grass-roofed buildings. The story of life, death, and rebirth told symbolically through the snake and goddess is the same story of life, death, and rebirth that science tells today, as genes transfer from parents to children. The interdependency in early human societies

We do not see the world directly, we see a picture or version of it, of how it hangs together, of what it means.

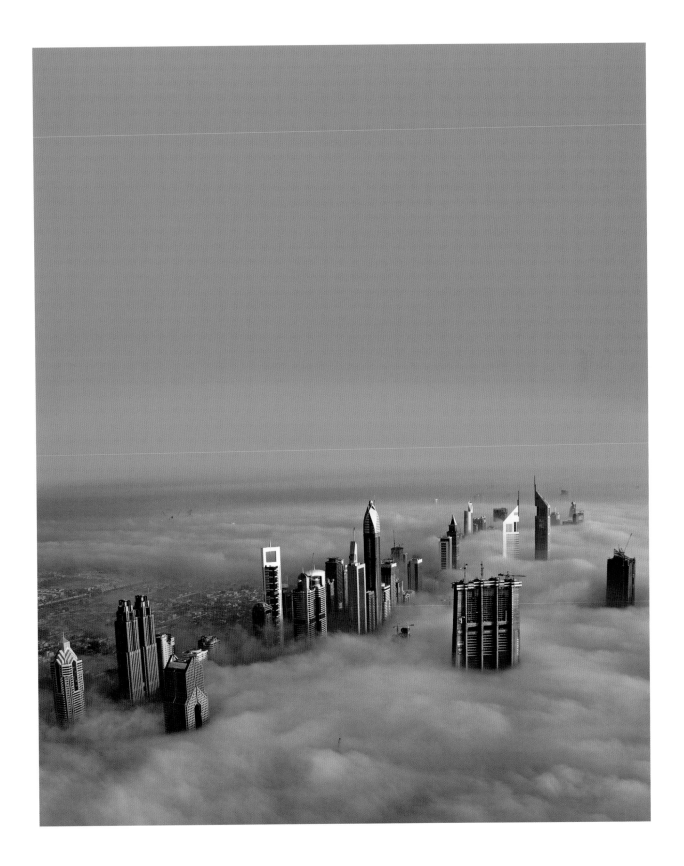

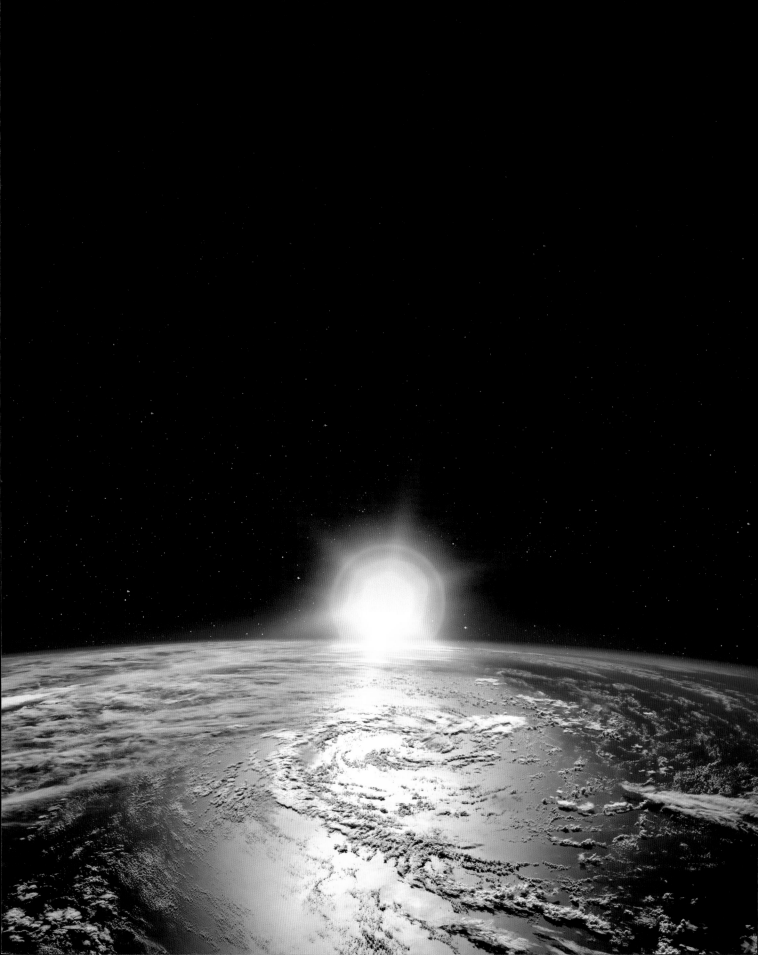

returns as connectivity through the Internet. We are relearning what the Dagara tribe knew—*you are my other self*. In viruses, global economics, and ecological consequences, we experience anew that *the other is us*.

The new connectivity is not a closed circle. Pattern and the unpredictable are both at play. We start to see repeating design and its infinite variation at macro and micro scales and from every angle.

While we do not know exactly how the future will unfold, we can look at the current world through the lens of process, participation, and paradox. Dynamic change will not cease; what we do affects the system. We can start imagining with a viewpoint that considers all directions, with the assumption of possibility, with acceptance of invisible forces, with respect for unknowable consequences.

The future is embedded in the present. As Martha Graham reminds us, an artist does not see ahead of her time, she sees in her time what others miss. To deeply see the present, we need to embrace paradox, hold opposites, and accept complexities with infinite causes and consequences. As scary as change is, the good news is that we are wired for adaptation. With open minds and fresh eyes, we can thrive during times of change.

We were nature-centered, then human-centered, and now we become planet-centered. Our understanding of the world evolved from a flat circle to a line of progress to global connections. Now we become conscious of our planet as a whole, a single living organism, and we relearn our place in the vast cosmos.

Shape cues us to a mindset. Being able to recognize past mindsets can alert us to current change, teach us to enlarge our lens, and warn us not to mistake our mental map for full reality. We live within the maps we create. Changing the mental map will change who we are.

To think out of the box, we need to see the boxes we have been in. Looking back at Stonehenge, skyscrapers, and views of Earth from space, we understand freshly that:

We shape our world, and then it shapes us.

References

CHAPTER 1

"...what it means." King's College Chapel exhibit, Cambridge University, England. 1996.

"...as we are." Anaïs Nin quoting the Talmud in: Nin, Anaïs. *Seduction of the Minotaur*. Chicago: Swallow Press, 1961, 124.

"... approximately 10,000 to 5000 BC." Stearns, Peter N. "The Neolithic Revolution," in *A Brief History of the World*. Lecture from the Great Courses, 2007, 20 & 28.

"...in twenty-four hours." NASA. "Make Contact: Astronaut Greg Chamitoff Answers Your Questions." NASA. Accessed September 16, 2015. http://www.nasa.gov/mission_pages/station/main/qa_week3.html.

"...above the altar." Saward, Jeff. "The Chartres Cathedral Labyrinth." 2003. Labyrinths & Mazes Resource Centre, Photo Library & Archive. Accessed February 11, 2016. http://www.labyrinthos.net/chartresfaq.html.

"...behind the time." Graham, Martha. quoted in *The Observer Magazine*. July 8, 1979.

"...source of information." Anderson, Heidi Milia. 1969. "Dale's Cone of Experience." Accessed February 1, 2016. https://www.etsu.edu/uged/etsu1000/documents/Dales_Cone_of_Experience.pdf.

"...our brain's capacity." Logothetis, Nikos. "Visual Perception—Psychophysics, Physiology and fMRI Studies." Max Planck Institute for Biological Cybernetics. Last modified July 26, 2015. http://www.kyb.tuebingen.mpg.de/research/dep/lo/visual-perception.html.

"...shape, shapes us." Similar to Winston Churchill quote: "We shape our buildings; thereafter, they shape us." House of Lords meeting October 28, 1943.

"...are the mapmakers." Gopal, Suchi quoted by Moran, Barbara. "Mapmaker/Matchmaker Suchi Gopal and the Power of Maps." *Bostonia Magazine* 2015 (Summer). http://www.bu.edu/bostonia/wpassets/issues/summer15/mapmaker.pdf.

"...does to himself." Translation from Chief Seattle's speech in the Suquamish language, attributed to Ted Perry, and to notes from Dr. H. A. Smith. "Early Reminiscences. Number 10. Scraps from a Diary. Chief Seattle—a Gentleman by Instinct." *Seattle Sunday Star*, October 29, 1887, 3.

"...comes in curves." Carpenter, Edmund Snow, Frederick Varley, and Robert Flaherty. *Eskimo*. Toronto: University of Toronto Press, 1959, 16.

"...within a larger oval." Ayo, Yvonne. *Eyewitness Books: Africa*. New York: Alfred Knopf, 1995, 16–17.

"...for sacred ceremonies." Sofaer, Anna. "The Primary Architecture of the Chacoan culture: A Cosmological Expression," in *Anasazi Architecture and American Design*. Edited by Baker H. Morrow and V. B. Price. Albuquerque: University of New Mexico Press, 1997. Accessed October 14, 2015. http://www.solsticeproject.org/primarch.htm.

"...a protecting ancestor." Gerster, Georg. *The Past from Above*. Edited by Charlotte Trümpler. Los Angeles: Getty Publications, 2005, 108.

"...common circular courtyard." Survival International. "The Yanomami." Accessed May 5, 2014. http://www.survivalinternational.org/tribes/yanomami.

"...ditches called henges." Burl, Dr. Aubrey. *The Stone Circles of Britain, Ireland and Brittany*. New Haven: Yale University Press, 2005, 87.

"...ripples of time." Knudsen, Eva Rask. *The Circle and the Spiral: A Study of Australian and New Zealand Maori Literature*. New York: Rodopi, 2004, 285.

"...part of a single whole." Ackerman, Kenneth J. "The Dreaming, an Australian World View." University of Delaware. Accessed July 13, 2016. https://www1.udel.edu/anthro/ackerman/dreaming.pdf.

"...not a maze." Conty, Patrick. *The Genesis and Geometry of the Labyrinth: Architecture, Hidden Language, Myths, and Rituals*. Rochester, VT: Inner Traditions, 2002, 16.

"...the nation's hoop." Neihardt, John G. *Black Elk Speaks: Being the Life Story of a Holy Man of the Oglala Sioux as told through John G. Niehardt (Flaming Rainbow)*. Lincoln: University of Nebraska Press, 1972, 194–196.

"...life cycle ceremonies." Milne, Courtney. *Sacred Places in North America: A Journey into the Medicine Wheel*. New York: Stewart, Tabori & Chang, 1994/1995, 9–10.

"...Bushmen in Africa." Van der Post, Laurens. *The Heart of the Hunter: Customs and Myths of the African Bushman*. San Diego: Harvest/HBJ Book, 1961, 183.

"...life force itself." Gimbutas, Marija. *The Language of the Goddess*. San Francisco: Harper & Row, 1989, 316.

"...around 6000 BC." Mythology Limited. *Joseph Campbell: Transformations of Myth Through Time*. New York: Harper & Row, 1990, 51.

"...a continuous circle." Gimbutas, Marija. *The Language of the Goddess*. San Francisco: Harper & Row, 1989, 121.

"...imitating python movements." Purce, Jill. *The Mystic Spiral: Journey of the Soul*. New York: Thames & Hudson, 2007, 90.

"...knowledge, knowledge manifest." Prechtel, Martin. *Secrets of the Talking Jaguar*. New York: Putnam Penguin, 1999, 165.

"...the next life." Gimbutas, Marija. *The Language of the Goddess*. San Francisco: Harper & Row, 1989, 154.

"...my other self." Some, Maladoma. Nine Gates Seminar, Santa Barbara, CA. Talk and conversation with Lois Stark, 1996. 1997.

"...only the present tense." Hoebel, Adamson E. *Man in the Primitive World, An Introduction to Anthropology*. 2nd ed. New York: McGraw-Hill, 1958, 568.

"...and Grandfather Canis." Van der Post, Laurens. *Patterns of Renewal*. Pendle Hill, 1962, 3. Pendle Hill Pamphlet Number 121.

"...and the moon." Epes-Brown, Joseph. *Teaching Spirits: Understanding Native American Religious Traditions*. New York: Oxford University Press, 2001, 113.

"...was considered kin." Neihardt, John G. *Black Elk Speaks: Being the Life Story of a Holy Man of the Oglala Sioux as told through John G. Niehardt (Flaming Rainbow)*. Lincoln: University of Nebraska Press, 1972, 2.

"...about his people." Survival International. "On the 'wild.' Human Imagination and Tribal Peoples." Accessed October 14, 2015. http://www.survivalinternational.org/articles/3174-wilderness-the-human-imagination-and-tribal-peoples.

"...the Taurari tree." Survival International. "Guardians of the World's Rainforests, Yanomami." Accessed June 5, 2013. http://www.survivalinternational.org/galleries/forest-peoples#7.

"...poison arrow heads." Bearak, Barry. "For Some Bushmen, a Homeland Worth the Fight," *The New York Times*, November 4, 2010. Accessed June 5, 2013. http://www.nytimes.com/2010/11/05/world/africa/05bushmen.html?_r=0.

"...of snow-covered terrain." Carpenter, Edmund Snow, Frederick Varley, and Robert Flaherty. *Eskimo*. Toronto: University of Toronto Press, 1959, 13.

"...storms days ahead." Davis, Wade. *The Wayfinders: Why Ancient Wisdom Matters in the Modern World*. Toronto: Anansi, 2009, 52–59.

"...of the kill." Hoebel, Adamson E. *Man in the Primitive World, An Introduction to Anthropology*. 2nd ed. NY: McGraw-Hill, 1958, 187.

"...toward early farming." Wilford, John Noble. "Tracing Origins of Farming: Genetic Studies Fix Locations." *The New York Times*, November 20, 1997.

"...the new moon." Saitoti, Tepilit Ole. *The Worlds of a Maasai Warrior, An Autobiography*. Berkeley: University of California Press, 1986, 27–29, 34–35, 110–111.

"...of moving trains." InterTribal Buffalo Council. "Slaughter of the Buffalo." Last modified August 4, 2015. Accessed October 14, 2015. http://itbcbuffalo.com/node/22.

"...as an enemy." Van der Post, Laurens. *Patterns of Renewal*. Pendle Hill, 1962, 3. Pendle Hill Pamphlet Number 121.

"...ago changed radically." Smithsonian Institution. "Homo sapiens." Accessed May 5, 2014. http://humanorigins.si.edu/evidence/human-fossils/species/homo-sapiens.

"...around 10,000 BC." Stearns, Peter N. "The Neolithic Revolution," in *A Brief History of the World*. Lecture from the Great Courses, 2007, 28.

"...and beans following." Wadley, Greg and Angus Martin. "The Origins of Agriculture: A Biological Perspective and a New Hypothesis." *Australian Biologist* 6 (1993): 96–105.

"...in Northern China." Ibid.

"...tens of thousands." Stearns, Peter N. "The Neolithic Revolution," in *A Brief History of the World*. Lecture from the Great Courses, 2007, 20.

"...and Grandfather Canis." Van der Post, Laurens. *Patterns of Renewal*. Pendle Hill, 1962, 3. Pendle Hill Pamphlet Number 121.

"...or Forest Water." Native American female names—Native American Baby Names, Amadahy means Forest Water, Cherokee; Aiyana means Eternal Blossom, from *2002–2013 Baby Name Guide*, www.babynameguide.com/categorynativeamerican.

"...tall stone pillars." Robinson, Andrew. *The Story of Writing: Alphabets, Hieroglyphs, and Pictograms*. London: Thames & Hudson, 1995, 16.

CHAPTER 3

"...out his money." NPR. "The Real Meaning of Nursery Rhymes." October 2, 2005. Accessed February 11, 2016. http://www.npr.org/templates/story/story.php?storyId=4933345.

"...both, I hope." Conversation with Lois Farfel Stark while filming in Abu Dhabi in 1968 as part of NBC News crew.

"...its defensive walls." Guisepi, R. A. "The First Towns: Seedbeds of Civilization; The Origins of Civilizations." History-world.org. Accessed March 4, 2014. http://history-world.org/firsttowns.htm.

"...together like Legos." Unesco.org. "The Neolithic Site of Çatalhöyük." Accessed March 4, 2014. http://whc.unesco.org/uploads/nominations/1405.pdf.

"...appearing in 2650 BC." Guisepi, Robert, ed. "Ancient Civilizations: The Requirement and Patterns to Development." World-history.org. Accessed March 4, 2014. http://history-world.org/ancient_civilization.htm.

"...in Ur, Iraq." Crawford, Harriet. *Ur: The City of the Moon God*. NY: Bloomsbury Academic, 2015, 84.

"...cities in Mesoamerica." Kirkwood, J. Burton. *The History of Mexico: Second Edition*. Connecticut: Greenwood Press, 2009, 19.

"...populations of thirty thousand." Maqbool, Aleem. "Mohenjo-daro: Could this ancient city be lost forever?" BBC. Accessed June 26, 2012. http://www.bbc.co.uk/news/magazine-18491900.

"...high protective wall." Hathaway, Bruce. "Endangered Site: Chan Chan, Peru." *Smithsonian*, March 2009. Accessed November 7, 2013. http://www.smithsonianmag.com/travel/Endangered-Cultural-Treasures-Chan-Chan-Peru.html.

"...top for rituals." Martell, Hazel Mary, ed. Cynthia O'Neill, Ruth Nason, Catherine Headlam. *The Kingfisher Book of the Ancient World from the Ice Age to the Fall of Rome*. New York: Kingfisher Publications, 2001, 20.

"...workforce of twenty thousand." Franz Löhner. "Building the Great Pyramid." Last modified 2006. Accessed October 14, 2015. http://www.cheops-pyramide.ch/khufu-pyramid/pyramid-workers.html.

"...to the seasons." Malström, Vincent. "Tikal." Dartmouth. Accessed August 7, 2013. http://www.dartmouth.edu/~izapa/tikal.html.

"...days of the year." National Geographic. "Chichen Itza Guide." *National Geographic*. http://travel.nationalgeographic.com/travel/world-heritage/chichen-itza/.

"...150,000 to gather." Millon, René. "The Place Where Time Began: An Archaeologist's Interpretation of What Happened in Teotihuacan History." In *Teotihuacan: Art from the City of the Gods*. Edited by Kathleen Berrin and Esther Pasztory. New York: Thames & Hudson, 1993, 18.

"...continuing for millennia." African World Heritage Sites. "Archaeological Sites of the Island of Meroe-Sudan." African-WorldHeritageSites.org. Accessed May 6, 2014. http://www.africanworldheritagesites.org/cultural-places/ancient-civilisations-of-the-nile/meroe.html.

"...transcendent god Shiva." Kaur, Ramandeep. "Brihadeeswara Temple: An Architectural Marvel of Ancient India." Maps of India.com, April 24, 2013. Accessed August 21, 2013. http://www.mapsofindia.com/my-india/travel/brihadeeswara-temple-an-architectural-marvel-of-ancient-india.

"...by a single worker." Ford. "Innovation." https://corporate.ford.com/innovation/100-years-moving-assembly-line.html.

"...houses a day." McQuiston, John T. "If You're Thinking of Living in: Levittown." *The New York Times*, November 27, 1983. Accessed February 2, 2016. http://www.nytimes.com/1983/11/27/realestate/if-you-re-thinking-of-living-in-levittown.html?pagewanted=all.

"...was 'Straight Lines'." Lois Stark conversation with General H. Norman Schwarzkopf at James A. Baker III Institute for Public Policy of Rice University lecture, September 18, 1998.

"...are genetically identical." Highfield, Roger. "DNA Survey Finds All Humans Are 99.9pc the Same." *The Telegraph*, December 20, 2002. Accessed January 1, 2016. http://www.telegraph.co.uk/news/worldnews/northamerica/usa/1416706/DNA-survey-finds-all-humans-are-99.9pc-the-same.html.

"...in distinctive ways." Haviland, William A. et al. *Anthropology: The Human Challenge*. Belmont, CA: Wadsworth, Cengage Learning, 2011, 47.

"...that perpetuate themselves." Wiener, Norbert. *The Human Use of Human Beings*. Boston: De Capo Press, 1954, 96.

"...from the rocks." Merin, Gili. "AD Classics: Niterói Contemporary Art Museum / Oscar Niemeyer." Architecture Daily.com, August 21, 2013. Accessed June 10, 2013. http://www.archdaily.com/417751/ad-classics-niteroi-contemporary-art-museum-oscar-niemeyer/.

"...surroundings change me." Aida Mahumdova quoted in Conway, Megan. "The Emergence of Azerbaijan's Ancient Capital City, Baku." *Wall Street Journal*, February 13, 2014. Accessed June 10, 2014. http://www.wsj.com/articles/SB10001424052702303942404579360882422006564.

"...is information held?" Lois Stark conversation with James Watson at University of Houston Farfel Lecture, April 7, 2005.

"...of genetic possibilities." J Craig Venter Institute. "First Self-Replicating Synthetic Bacterial Cell." Accessed January 28, 2016. http://www.jcvi.org/cms/research/projects/first-self-replicating-synthetic-bacterial-cell/overview/.

"...in his home." Strohmeyer, Robert. "The Seven Worst Tech Predictions of All Time." *PC World*. December 31, 2008.

"...of the population." West, Darrell M. and Jack Karsten. "Rural and Urban America Divided by Broadband Access." Brookings Institute, July 7, 2016. Accessed August 30, 2016. https://www.brookings.edu/blog/techtank/2016/07/18/rural-and-urban-america-divided-by-broadband-access/.

CHAPTER 4

"...having new eyes." Proust, Marcel. *The Captive and The Fugitive*. Translated by C.K. Scott Moncrieff and Terence Kilmartin. New York: Random House, 1999.

"...must be mapped." Capra, Fritzjof. *The Web of Life*. New York: Doubleday, 1996, 81.

"...a double helix…" Cold Spring Harbor Laboratory. "The DNA Molecule Is Shaped Like a Twisted Ladder." Accessed November 9, 2016. http://www.dnaftb.org/19/bio03.html.

CHAPTER 5

"...in the Universe." Muir, John. *My First Summer in the Sierra*. Boston and New York: Houghton Mifflin, 1911, 98.

"...on mobile devices." Time Staff. "Michael Tilson Thomas." TIME.com, April 4, 2011. Accessed October 14, 2015. http://content.time.com/time/specials/packages/article/0,28804,2058044_2060338_2060213,00.html.

"...of open interaction." Waldrop, Mitch. "DARPA and the Internet Revolution." 50 Years of Bridging the Gap. *DARPA*. April 2009. 78–85. Retrieved July 23, 2013. http://www.darpa.mil/about/history/history.aspx.

"...since Rockefeller Center." Hudson Yards. "The Story." Accessed January 31, 2017. http://www.hudsonyardsnewyork.com/about/the-story/.

"...a mouse click." Li, Shan. "Amazon Overtakes Wal-Mart as Biggest Retailer." *LA Times*. Last Modified July 24, 2015. Accessed October 14, 2015. http://www.latimes.com/business/la-fi-amazon-walmart-20150724-story.html.

"...method of presentation." Nadel, Dan. "Q+A - Edward Tufte." *Print Magazine*, December 27, 2007. Accessed October 14, 2015. http://www.printmag.com/article/qa_edward_tufte/.

"...dedicated to sight." Logothetis, Nikos. "Visual Perception—Psychophysics, Physiology and fMRI Studies." Max Planck Institute for Biological Cybernetics. Last modified July 26, 2015. http://www.kyb.tuebingen.mpg.de/research/dep/lo/visual-perception.html.

"...read or hear." Anderson, Heidi Milia. 1969. "Dale's Cone of Experience." Accessed February 1, 2016. https://www.etsu.edu/uged/etsu1000/documents/Dales_Cone_of_Experience.pdf.

"...without an image." Aristotle. *Works of Aristotle. Vol 1*. Chicago: Encyclopedia Britannica, Inc., 1952, 663. Referenced by Arrien, Angeles. *Signs of Life: The Five Universal Shapes and How to Use Them*. New York: Penguin Putnam, 1992, 19.

"...are called 'screenagers'" Rushkoff, Douglas. *Playing the Future: How Kids' Culture Can Teach Us to Thrive in an Age of Chaos*. New York: Harper Collins, 1996, 3.

"...and neuron regeneration." American Academy of Pediatrics, Committee on Public Education. "Children, Adolescents and Television." *Pediatrics*. 2001; 107 (2): 423–426.

"...hour a day." Kaiser Foundation Report. "Generation M2: Media in the Lives of 8- to 18-Year-Olds." January 20, 2010. Accessed August 30, 2016. http://kff.org/other/event/generation-m2-media-in-the-lives-of/.

"...and with us." "The Playboy Interview: Marshall McLuhan." *Playboy Magazine*, March 1969. https://www.nextnature.net/2009/12/the-playboy-interview-marshall-mcluhan/

"...searches for nutrients." Fleming, Nic. "Plants Talk to Each Other Using an Internet of Fungus." BBC. Last modified November 11, 2014. Accessed October 14, 2015. http://www.bbc.com/earth/story/20141111-plants-have-a-hidden-internet.

"...a network design." Fricker, M.D., Boddy, L. and Bebber, D.P. (2007) "Network Organization of Mycelial Fungi." In: *The Mycota. Vol. VIII, Biology of the Fungal Cell* (2nd ed). Eds R.J. Howard and N.A.R Gow., 341. Retrieved August 20, 2013. http://www.cabdyn.ox.ac.uk/complexity_PDFs/Publications%202007?Fricker%20Mycota%20proof.pdf.

"...but by networking." Margulis, Lynn and Dorion Sagan. *Microcosmos: Four Billion Years of Evolution from Our Microbial Ancestors*. New York: Summit Books, 1986, 19.

"...response to stress." Ben-Jacob, Eshel. "Realizing Social Intelligence of Bacteria." Tel Aviv University. Accessed January 28, 2015. http://tamar.tau.ac.il/~eshel/html/intelligence_of_Bacteria.html.

"...humans on Earth." Ben-Jacobs, Eshel. "Realizing Social Intelligence of Bacteria." Tel Aviv University. Accessed January 28, 2015. http://tamar.tau.ac.il/~eshel/realizing_bacteria.html.

"...contact by contact." Schlanger, Zoe. "An Algorithm Spotted the Ebola Outbreak Nine Days Before WHO Announced It." *Newsweek*. Last modified August 11, 2014. Accessed October 14, 2015. http://www.newsweek.com/algorithm-spotted-ebola-outbreak-9-days-who-announced-it-263875.

"...uploaded from Earth." NASA. "Space Station 3-D Printer Builds Ratchet Wrench to Complete First Phase of Operations." Last modified July 30, 2015. Accessed October 14, 2015. http://www.nasa.com/mission_pages/station/research/news/3Dratchet_wrench

"...in two decades." Rutkin, Aviva Hope. "Report Suggests Nearly Half of U.S. Jobs are Vulnerable to Computerization." Last modified September 12, 2013. Accessed October 14, 2015. http://www.technologyreview.com/view/519241/report-suggests-nearly-half-of-us-jobs-are-vulnerable-to-computerization/.

"...a driverless car." Alex Hern. "Are Driverless Cars the Future of Uber?" *The Guardian*, February 3, 2015. Accessed February 10, 2016. http://www.theguardian.com/technology/2015/feb/03/are-driverless-cars-the-future-of-uber.

"...downloaded by anyone." Carmon, Yigal and Steven Stalinksy. "Terrorist Use of U.S. Social Media Is a National Security Threat." *Forbes* Opinion, January 20, 2015. Accessed January 21, 2016. http://www.forbes.com/sites/realspin/2015/01/30/terrorist-use-of-u-s-social-media-is-a-national-security-threat/#10c2c20c12d0http://www.nasa.gov/mission_pages/station/research/news/3Dratchet_wrench/.

"...that created them." Einstein, Albert. Original wording believed to be: "to let the people know that a new type of thinking is essential . . . if mankind is to survive and move toward higher levels." quoted in "Atomic Education Urged by Einstein." *The New York Times*, May 25, 1946.

"...floating in space." Nasso, Angelina. McCLain Gallery Houston Artist's Reception. September 18, 2003.

"...the first time." Neil deGrasse Tyson, interviewed by Rose, Charlie. "Astrophyscicist Neil deGrasse Tyson's One-Man Mission." cbsnews.com, March 22, 2015. Accessed October 14, 2015. http://www.cbsnews.com/news/neil-degrasse-tyson-astrophysicist-charlie-rose-60-minutes/.

"...return as humanitarians." Mitchell Edgar, ed. Kevin W. Kelley. *The Home Planet*. Addison-Wesley: Reading, MA, 1988, 137.

"...Spain, Malaysia and Denmark." NASA, April 28, 2016 "International Space Station Facts and Figures." Accessed June 20, 2017. NASA.gov/mission_pages/station/main/onthestation/facts_and_figures.html.

"...in particle physics." CERN. "The Large Hadron Collider." Accessed October 14, 2015. http://home.web.cern.ch/topics/large-hadron-collider.

"...allies and enemies." CoEPP. "CERN's Large Hadron Collider." Accessed October 14, 2015. http://www.coepp.org.au/discover/cerns-large-hadron-collider.

"...from thirty-six countries." CERN. "Processing LHC Data." Accessed January 27, 2016. http://cds.cern.ch/record/1541893?ln=it.

"...be behind things." Einstein, Albert. Remembering seeing a magnetic compass needle point north at age 4. Paul Arthur Schilpp. *Albert Einstein: Philosopher-Scientist*. Le Salle, Illinois: Open Court, 1998.

"...cloud-shaped nebulae." Weaver, Donna and David Salisbury. "A New Twist on an Old Nebula." Hubble site. Last modified December 6, 2014. Accessed October 13, 2015. http://hubblesite.org/newscenter/archive/releases/2004/32/.

"...by being alive." Neil deGrasse Tyson quoted in *Time* magazine. "10 Questions for Neil deGrasse Tyson." YouTube Video. Accessed January 27, 2016. https://www.youtube.com/watch?v=wiOwqDmacJo.

"...will flow next." Miller, Peter. "How Do We Know It's Happening?" *National Geographic*, October 15, 2015. Accessed November 1, 2016. http://ngm.nationalgeographic.com/2015/11/climate-change/pulse-of-the-planet-text.

"...are all mortal." Kennedy, John F. "President Kennedy Nuclear Test Ban Treaty Speech, American University 1963 Commencement." American University. Accessed February 10, 2016. http://www1.american.edu/media/speeches/Kennedy.htm.

"...around the Earth." "The Torus—Dynamic Flow Process." Cosmometry.net. http://www.cosmometry.net/the-torus---dynamic-flow-process.

"...color of bones." Chesi, Gert. *The Last Africans*. Cape Town, Johannesburg: C Struik Publishers, 1977, 225.

"...the landscape first." Chua et al. "Cultural Variation in Eye Movements during Scene Perception." Proceedings of the National Academy of Sciences. 12629–12633.

"...at a faster rate." Nisbett, Richard E. *The Geography of Thought*. New York: Free Press, 2003, xix.

"...set of challenges." Kissinger, Henry. Goldberg, Jeffrey. "The Lessons of Henry Kissinger." *The Atlantic*. December 2016.

"...the common potato." Toporek, Sergio. Solar System Exploration Research Virtual Institute. "We Originated in the Belly of a Star." Accessed December 16, 2015. http://sservi.nasa.gov/articles/beware-of-images/.

"...only five percent." NASA. "Dark Energy, Dark Matter." Nasa.gov. http://science.nasa.gov/astrophysics/focus-areas/what-is-dark-energy/.

"...last six decades." Human Security Report Project. "Human Security Report 2013: The Decline in Global Violence: Evidence, Explanation, and Contestation." Vancouver: Human Security Press, 2013.

"...outperformed intelligence analysts..." Tetlock, Philip E. and Gardner, Dan. *Superforecasting: The Art and Science of Prediction*. New York: Crown Publishers, 2015.

"...brain as imagination." Eagleman, David. *The Brain: The Story of You, A Companion to the PBS Series*. New York: Pantheon Books, 2015, 24-26.

"...wired for adaptation." Ibid., 8.

Further Reading

Antonelli, Paola, ed. *Design and the Elastic Mind*. New York: Museum of Modern Art, 2008.

Archive for Research in Archetypal Symbolism (ARAS). *The Book of Symbols: Reflections on Archetypal Images*. Edited by Ami Ronnberg. Cologne, Germany: Taschen, 2010.

Arthus-Bertrand, Yann. *Earth From Above: 365 Days*. New York: Abrams, 2003.

Barabási, Albert-László. *Bursts: The Hidden Patterns Behind Everything We Do, from Your E-mail to Bloody Crusades*. New York: Penguin, 2010.

Barabási, Albert-László. *Linked: How Everything Is Connected to Everything Else and What It Means for Business, Science, and Everyday Life*. Philadelphia: Perseus Publishing, 2014.

Barber, Elizabeth Wayland and Paul T.Barber. *When They Severed Earth from Sky: Human Mind Shapes Myth*. Princeton: Princeton University Press, 2006.

Barber, Peter, ed. *The Map Book*. New York: Walker and Company, 2005.

Barrow, John D. *Cosmic Imagery: Key Images in the History of Science*. New York: W.W. Norton, 2008.

Baudez, Claude and Sydney Picasso. *Lost Cities of the Maya (Discoveries)*. Translated by Caroline Palmer. New York: Abrams, 1992.

Beck, Mary Giraudo. *Potlatch: Native Ceremony and Myth on the Northwest Coast*. Illustrated by Marvin Oliver. Portland: Alaska Northwest Books, 2013.

Beckwith, Carol and Angela Fisher. *African Ceremonies*. New York: Abrams, 2002.

Bejan, Adrian and J. Peder Zane. Design in Nature: How the Constructal Law Governs Evolution in Biology, Physics, Technology, and Social Organizations. New York: Anchor Books, 2012.

Berger, John. *Ways of Seeing*. New York: Penguin Books, 1977.

Black, Jeremy, ed. *Atlas of World History: Mapping the Human Journey*. London: Dorling Kindersley, 1999.

Bourne, Edmund J. *Global Shift: How a New Worldview Is Transforming Humanity*. Oakland: New Harbinger Publications, 2008.

Burenhult, Goran. *The First Humans: Human Origins and History to 10,000 B.C. (Illustrated History of Humankind, Vol. 1)*. New York: Harper Collins, 1993.

Campbell, Joseph and Bill Moyers, coll. *The Power of Myth*. New York: Anchor Books, 2011.

Campbell, Joseph. *Historical Atlas of World Mythology, Vol. 1: The Way of the Animal Powers, Part 1, Mythologies of the Primitive Hunters and Gatherers*. New York: Harper Collins, 1988.

Campbell, Joseph. *Historical Atlas of World Mythology, Vol. II: The Way of the Seeded Earth, Part 3: Mythologies of the Primitive Planters: The Middle and Southern Americas*. New York: Harper Collins, 1989.

Chatwin, Bruce. *The Songlines*. New York: Penguin, 1988.

Cohen, David. *The Circle of Life: Rituals from the Human Family Album*. San Francisco: HarperSanFransisco, 1991.

Diamandis, Peter H. and Steve Kotler. *Abundance: The Future Is Better Than You Think*. New York: Simon and Schuster, 2012.

Diamandis, Peter H. and Steve Kotler. *Bold: How to Go Big, Create Wealth and Impact the World*. New York: Simon and Schuster, 2016.

Diamond, Jared. *Guns, Germs, and Steel: The Fates of Human Societies*. New York: W.W. Norton, 1999.

Doczi, Gyorgy. *The Power of Limits: Proportional Harmonies in Nature, Art and Architecture*. Boston: Shambhala Publications, 2005.

Doniger, Wendy. *The Implied Spider: Politics and Theology in Myth*. New York: Columbia University Press, 2010.

Ehrenberg, Margaret. *Women in Prehistory*. London: British Museum Publications, 1989.

Eisler, Riane. *The Chalice and the Blade: Our History, Our Future*. New York: Harper and Row, 1987.

Elkins, James. *How to Use Your Eyes*. New York: Routledge, 2000.

Erlande-Brandenburg, Alain. *Cathedrals and Castles: Building in the Middle Ages*. New York: Abrams, 1995.

Escalante, Roberto Ojeda and Juvenal Alvarez Espinoza. *The History of the Inkas*. Cusco: Regesa, 2005.

Field, Michael and Martin Golubitsky. *Symmetry in Chaos: A Search for Pattern in Mathematics, Art and Nature*. Philadelphia: Society for Industrial and Applied Mathematics, 2009.

Foucault, Michel. *The Order of Things: An Archaeology of the Human Sciences*. New York: Random House, 1994.

Gardner, Dudley A. and Val Brinkerhoff. *Architecture of the Ancient Ones*. Edited by Suzanne Taylor. Layton, UT: Gibbs Smith, 2000.

Goerner, Sally. *Chaos and the Evolving Ecological Universe (The World Futures General Evolution Studies)*. Perth: Gordon and Breach Publishers, 1994.

Goodrich, Norma Lorre. *Priestesses*. New York: Harper Perennial, 1990.

Guaitoli, M.T. and S. Rambaldi. *Lost Cities from the Ancient World*. New York: Barnes and Noble Books, 2006.

Harari, Yuval Noah. *Sapiens: A Brief History of Mankind*. New York: Harper Collins, 2015.

Hart-Davis, Adam. *History: The Definitive Visual Guide*. London: DK, 2007.

Hayward, Jeremy W. *Letters to Vanessa: On Love, Science and Awareness in an Enchanted World*. Boston: Shambhala Publications, 1997.

Herman, Amy E. *Visual Intelligence: Sharpen Your Perception, Change Your Life*. Boston: Houghton Mifflin Harcourt, 2016.

Hesselbein, Frances, Marshall Goldsmith, and Richard Beckhard, eds. *The Community of the Future*. New York: Drucker Foundation, 1998.

Hock, Dee. *Birth of the Chaordic Age*. San Francisco: Berrett-Koehler, 1999.

Hooker, J.T. *Reading the Past: Ancient Writing from Cuneiform to the Alphabet*. Berkeley: University of California Press, 1990.

Hunt, Norman Bancroft. *Historic Atlas of Ancient Mesopotamia*. New York: Checkmark Books, 2004.

Jean, Georges. *Writing: The Story of Alphabets and Scripts*. New York: Abrams, 1992.

Jellicoe, Geoffrey Alan and Susan Jellicoe. *The Landscape of Man: Shaping the Environment from Prehistory to the Present Day*. London: Thames & Hudson, 1995.

Jenny, Hans. *Cymatics: A Study of Wave Phenomena & Vibration.* MACROmedia Publishing, 2001.

Johnson, Steven. *Emergence: The Connected Lives of Ants, Brains, Cities, and Software.* New York: Scribner, 2001.

Jung, Carl. *Man and His Symbols.* New York: Doubleday, 1964.

Kelley, Kevin. *The Home Planet.* Boston: De Capo Press, 1988.

Knauer, Kelly. *TIME Great Discoveries: Explorations that Changed History.* New York: Time Books, 2009.

Kostof, Spiro. *The City Shaped: Urban Patterns and Meanings Through History.* New York: Bullfinch Press, 1991.

Kubler, George. *The Shape of Time: Remarks on the History of Things.* New Haven: Yale University Press, 1962.

Kuhl, Isabel. *50 Buildings You Should Know.* Munich: Prestel, 2007.

Kurzweil, Ray. *The Singularity Is Near: When Humans Transcend Biology.* New York: Viking, 2005.

Laszlo, Ervin, Stanislav Grof, and Peter Russell. *The Consciousness Revolution.* Las Vegas: Elf Rock Productions, 2003.

Lawlor, Robert. *Sacred Geometry: Philosophy and Practice.* London: Thames & Hudson, 1982.

Lewis-Williams, David and David Pearce. *Inside the Neolithic Mind.* London: Thames & Hudson, 2005.

Lobell, Mimi. "Spatial Archetypes." Quadrant: The Journal of the C.G. Jung Foundation, 1:2. 1977. http://works.bepress.com/quadrant/340/.

Macaulay, David. *Pyramid.* Boston: Houghton Mifflin Company, 1975.

Maybury-Lewis, David. *Millennium: Tribal Wisdom and the Modern World.* New York: Viking Press, 1996.

McNeill, J.R. and William McNeill. *The Human Web: A Bird's-Eye View of World History.* New York: W.W. Norton, 2003.

McTaggart, Lynne. *The Field: The Quest for the Secret Force of the Universe.* New York: Harper Collins, 2002.

Meadows, Donella H. *Thinking in Systems: A Primer.* White River Junction, VT: Chelsea Green Publishing Company, 2008.

Mohen, Jean-Pierre. *Megaliths: Sons of Memory.* New York: Abrams, 1999.

Morgan, Gareth. *Images of Organization.* Thousand Oaks, CA: Sage Publications, 2006.

Mumford, Lewis. *The City in History: Its Origins, Its Transformations, and Its Prospects.* San Diego: Harvest Books, Harcourt, 1989.

Narby, Jeremy. *Intelligence in Nature: An Inquiry into Knowledge.* New York: Penguin Group, 2005.

National Geographic Society. *Peoples and Places of the Past: The National Geographic Illustrated Cultural Atlas of the Ancient World.* Washington, D.C.: National Geographic Books, 1983.

National Geographic Society. *Splendors of the Past: Lost Cities of the Ancient World.* Edited by Merrill Windsor. Washington, D.C.: National Geographic Books, 1983.

Newcomb, Franc J. and Gladys A. Reichard. *Sandpaintings of the Navajo Shooting Chant.* New York: Dover Publications, 1989.

Norwich, John Julius. *The Great Cities in History.* London: Thames & Hudson, 2009.

O'Brien, Patrick K., ed. *Atlas of World History.* New York: Oxford University Press, 2010.

O'Donnell, Joan K, ed. *Here, Now and Always: Voices of the First Peoples of the Southwest.* Santa Fe: Museum of New Mexico Press, 2001.

Parrot, Andre. *Sumer: The Dawn of Art.* New York: Golden Press, 1961.

Pasztory, Esther. *Thinking with Things: Toward a New Vision of Art.* Austin: University of Texas Press, 2005.

Perkins, John and Shakaim Mariano Shakai Ijisam Chumpi. *Spirit of the Shuar: Wisdom from the Last Unconquered People of the Amazon.* Rochester, VT: Destiny Books, 2001.

Pinker, Steven. *How the Mind Works.* New York: W.W. Norton & Company, 2009.

Prechtel, Martin. *Long Life Honey in the Heart.* Berkeley: North Atlantic Books, 2004.

Prussin, Labelle. *African Nomadic Architecture: Space, Place and Gender.* Washington, D.C.: Smithsonian Institution Press, 1997.

Purce, Jill. *The Mystic Spiral: Journey of the Soul.* London: Thames & Hudson, 1980.

Ramo, Joshua Cooper. *The Age of the Unthinkable: Why the New World Disorder Constantly Surprises Us and What We Can Do About It.* New York: Little, Brown and Company, 2009.

Reichold, Klaus and Bernhard Graf. *Buildings That Changed the World*. Munich: Prestel, 1999.

Roaf, Michael. *Cultural Atlas of Mesopotamia and the Ancient Near East*. Edited by Michael March. New York: Facts on File, Inc., 1990.

Robinson, Andrew. *The Story of Writing: Alphabets, Hieroglyphs and Pictograms*. London: Thames & Hudson, 2007.

Ross, Norman P., ed. The Epic of Man. New York: Time Books, 1961.

Ryan, Joseph, ed. *Satellite Atlas of the World*. Auckland: Bramley Books, 1998.

Saitoti, Tepilit Ole. *Maasai*. Photographed by Carol Beckwith. New York: Abrams, 1981.

Scarre, Chris, ed. *Timelines of the Ancient World: A Visual Chronology from the Origins of Life to AD 1500*. London: Dorling Kindersley, 1993.

Schneider, Michael S. *A Beginner's Guide to Constructing the Universe: The Mathematical Archetypes of Nature, Art, and Science*. New York: Harper Collins, 1994.

Schuster, Carl and Edmund Carpenter. *Patterns That Connect: Social Symbolism in Ancient and Tribal Art*. New York: Abrams, 1996.

Shlain, Leonard. *The Alphabet Versus the Goddess: The Conflict Between World and Image*. New York: Penguin, 1998.

Somé, Malidoma Patrice. *Ritual: Power, Healing and Community*. New York: Penguin, 1997.

Stacey, Ralph D. *Complexity and Creativity in Organizations*. San Francisco: Berrett-Koehler Publishers, 1996.

Stephenson, Michael. *The Architecture Timecharts*. New Jersey: Chartwell Books, Inc., 2003.

Stevens, Payson R. and Kevin W. Kelley. *Embracing Earth: New Views of Our Changing Planet*. San Francisco: Chronicle Books, 1992.

Stevens, Peter S. *Patterns in Nature*. New York: Little, Brown and Company, 1974.

Tetlock, Phillip E. and Dan Gardner. *Superforecasting: The Art and Science of Prediction*. New York: Crown Publishers, 2016.

Thomas, Lewis. *The Lives of a Cell: Notes of a Biology Watcher*. New York: Penguin Books, 1978.

Watson, James D. and Andrew Berry. *DNA: The Secret of Life*. New York: Alfred A. Knopf, 2003.

Watson, James. D. *The Double Helix: A Personal Account of the Discovery of the Structure of DNA*. New York: Penguin Books, 1988.

Wheatley, Margaret J. *Leadership and the New Science: Learning about Organization from an Orderly Universe*. Oakland: Berrett-Koehler Publishers, 1994.

Wilber, Ken. *Eye to Eye: The Quest for the New Paradigm*. Boston: Shambhala Publications, 1996.

Wilczek, Frank. *A Beautiful Question: Finding Nature's Deep Design*. New York: Penguin Books, 2015.

Williamson, Ray A. *Living the Sky: The Cosmos of the American Indian*. Norman, OK: University of Oklahoma Press, 1987.

WIlson, E.O. *Consilience: The Unity of Knowledge*. New York: Alfred A. Knopf: 1998.

Image Credits and Sources

CHAPTER 1

Circle dance in Liberian forest settlement, 1969. Courtesy of
 Lois Stark.

President Tubman, Monrovia, Liberia, 1969. Courtesy of Lois Stark.

Troops marching, Monrovia, Liberia, 1969. Courtesy of Lois Stark.

Thatched huts in Liberian forest settlement, 1969. Courtesy of
 Lois Stark.

Initiation ceremony in Liberian forest settlement, 1969.
 Courtesy of Lois Stark.

Aerial view of Stonehenge. Copyright © 2010 Hans Elbers,
 Fotovlieger.nl.

Stonehenge, Wiltshire, England. Copyright Jaroslava V.
 Used under license from Shutterstock.com.

Illustration, King's Chapel. Artist: William Camden Edwards.
 From Library of Getty Research Institute.

King's college chapel, Cambridge, England. Copyright Adrian Zenz.
 Used under license from Shutterstock.com.

World airline route. Copyright John Sullivan. Adapted by a_trotskyite.

Photo, The Big Dipper, from *Cosmos* by Carl Sagan.
 Copyright © 1980 by Druyan-Sagan Associates, Inc.,
 formerly known as Carl Sagan Productions, Inc. Adapted by
 Holly Walrath. Used by permission.

Photo, The Great Bear, from *Cosmos* by Carl Sagan.
 Copyright © 1980 by Druyan-Sagan Associates, Inc.,
 formerly known as Carl Sagan Productions, Inc. Adapted by
 Holly Walrath. Used by permission.

Photo, Charles' Wain/Wagon, from *Cosmos* by Carl Sagan.
 Copyright © 1980 by Druyan-Sagan Associates, Inc.,
 formerly known as Carl Sagan Productions, Inc. Adapted by
 Holly Walrath. Used by permission.

Illustration, Heavenly Goddess. Artist: Kelly Ulkak Moss.

Illustration, Laptop Computer. Artist: Kelly Ulkak Moss. Adapted by Holly Walrath.

CHAPTER 2

Photo, spider web (cobweb) closed up background. Copyright SI Travel Photo and Video. Used under license from Shutterstock.com.

Photo, Bayaka pygmies in Central Africa. © Olivier Blaise. Used by permission.

Photo, Himba Village Namibia Africa. Copyright Marzia Franceschini. Used under license from Shutterstock.com.

Photo, bent timber Afar hut, Kenya. © 2011 Sebastian Morales.

Mammoth bone dome, Ukraine. Photographer C.M. Dixon. Used by permission from Heritage-Images.com.

Photo, Igloo in a winter mountain setting. Copyright Tyler Olson. Used under license from Shutterstock.com.

Photo, straw and mud sphere. Used by permission of John Oxley Library, State Library of Queensland Neg. 58731.

Aerial view of Masai village in nature's circle and goat herds near Lew Conservatory, Kenya, Africa. Copyright Joseph Sohm. Used under license from Shutterstock.com.

Aerial photo of Pueblo Bonito. Used by permission of Brad Shattuck/National Park Service.

Photo, remains of the Guatacondo Village in the Atacama Desert. Used by permission of Simon Urbina.

Photo, Yanomami communal house. © Dennison Berwick/Survival International. Used by permission.

Photo, Arapaho Camp, 1868. Source: Western History Collections, University of Oklahoma Libraries, Campbell 55.

Photo, Yellowmead Down. © 2010 Adam Sparkes.

Photo, Australian Aborigine, from Joseph Campbell's Historical Atlas of World Mythology. By P/Muller/Hao/Qui, Paris. Used with permission of the Joseph Campbell Foundation.

Photo, Labryinth. Lee34. Used under license from Shutterstock.com.

Photo, Big Horn Medicine Wheel, Big Horn, Wyoming, c. 1200 A.D. Courtesy of US Forest Service.

Photo, Praying Mantis, Sex (during). Used by permission from Catherine Chalmers, www.catherinechalmers.com.

Photo, Venus of Laussel. © V. Mourre / Inrap

Photo, Venus von Willendorf. © 2007 Matthias Kabel.

Photo, Double Figurines from Çatul Hüyük. Courtesy of Professor Michael Fuller, St. Louis Community College

Photo, Python initiation ritual, Bavenda tribe, South Africa. Photographer, Peter Carmichael.

Photo, Mnajdra temple complex. Used by permission of Jonathan Beacom.

Photo, Ouroborus: symbol of eternity. From the Chrysopoeia of Cleopatra, c. 900–1100 A.D. Courtesy WolfgangRieger.

Photo, egg-shaped grave, Nitra. Courtesy of Juraj Pavuk.

Photo, San Bushmen. Courtesy of Carly P. Larson.

Photo, Yanomani tribe. Photo © Fiona Watson. Courtesy of Survival International.

Photo, San bushmen going hunting. Copyright 2640ben. Used under license from Shutterstock.com.

Photo, Domestication of animals, Bonda, India. Photographer Alain Cheneviere.

Photo, Early writing table recording the allocation of beer. © 2012 BabelStone. Source: British Museum.

Photo, Sumerian account of silver for the governor. 2010 Gavin Collins. Source: British Museum.

Photo, Cuneiform Table from an Assyrian Trading Post. Erich Lessing/Art Resource, NY. Used by permission.

Photo, Law Code of Hammurabi. Photo: Hervé Lewandowki. ©RMN-Grand Palais / Art Resource, NY. Used by permission.

Photo, Head of Medusa. Artist Gian Lorenzo Bernini, c.1630. Copyright shutteroly. Used under license from Shutterstock.com.

Photo, The Miracle of St. George and the Dragon. Source: British Museum.

Photo, Dogok Dong condominium complex, Seoul, South Korea. Courtesy of Emerson.

Photo, Bedouin nomads. Courtesy of Lois Stark.

Photo, Sheik Zayed being filmed. Courtesy of Lois Stark.

Photo, Jubains. Photo courtesy of General Council Mayenne/ Jacques Naveau.

Photo, Ruins of old Hittite capital Hattusa, Turkey. Copyright Matyas Rehak. Used under license from Shutterstock.com.

Photo, Mohenjo Daro. Photo courtesy of James Look.

Photo, Harappa, Pakistan, 2200-1900 BC. Copyright © J. M. Kenoyer/Harappa.com. Courtesy of the Department of Ara-chaelogy and Museums, Government of Pakistan.

Photo, Exterior Gates, Chan Chan Peru. Courtesy of Jacob Metcalf, www.jacobmetcalf.net.

Photo, Fishnetlike Carvings, Chan Chan, Near Trujilo. Copyright Mikluha_Maklai. Used under licensed from Shutterstock.com.

Photo, ancient pyramids in sunset. Copyright pixelparticle. Used under license from Shutterstock.com.

Photo, Meroe pyramids in the sahara desert Sudan. Copyright © Martchan. Used under license from Shutterstock.com.

Photo, Restored Ziggurat Ancient Ur Sumerian Temple. Copyright Homo Cosmisco. Used under license from Shutterstock.com.

Photo, Teotihuacan Aztec Ruins. Copyright Alberto Loyo. Used under license from Shutterstock.com.

Photo, Pyramid Kukulcan El Castillo Chichenitza Chichen. Copy-right Sorin Colac. Used under licensed from Shutterstock.com.

Photo, Guatemala Mayan Ruins. Copyright Rafal Chcawa. Used under license from Shutterstock.com.

Photo, Angkor Wat. © Bjørn Christian Tørrissen, bjornfree.com.

Photo, Peruvudaiyar Kovil, Tamil Nadu, India. Courtesy of Devarajan K.

Photo, Heritage Buddist temple Borobudur complex in Yogijakarta in Java, Indonesia. Copyright © weltreisendertj. Used under license from Shutterstock.com.

Photo, Façade of the Milan Cathedral, Milano, Italy. © Pavel Vakhrushev. Used under license from Shutterstock.com.

Photo, King's College Chapel. ©Mark William Penny. Used under license from Shutterstock.com.

Photo, St. Michael's Church, Turku, Finland. Courtesy of Markus Koljonen.

Photo, Sight Towers, Petronas Kuala Lumpur. Copyright ahau1969. Used under license from Shutterstock.com.

Photo, The Shard, London. ©iStockphoto.com/valdisskudre.

Photo, Empire State Building. © Sean Pavone. Used under license from Shutterstock.com.

Photo, Aerial view of Manhattan. Copyright Luciano Mortula. Used under license from Shutterstock.com.

Photo, Central Park aerial view, Manhattan, New York. Copyright © T photography. Used under license from Shutterstock.com.

Photo, An Aerial view of the Levittown housing project in Pennsylvania. Photographer: Ed Latcham. Copyright © Everett Historical. Used under license from Shutterstock.com.

Photo, English row houses. Copyright ©iStockphoto.com/ HPuschmann.

Photo, Women at work during the First World War. Munitions Production, Chilwell, Nottinghamshire, England, UK, c. 1917. © Imperial War Museums (Q 30011). Used by permission.

Photo, Automat, New York, 1950s. Photographer: Bernice Abbott. Source: New York Public Library

Longitude and latitude lines. Source: Earth Observatory Office, NASA.

Russian office complex. © David Mark.

Photo, Dogok Dong condominium complex, Seoul, South Korea. Courtesy of Emerson.

Photo, skyscraper windows. Copyright © Venturelli Luca. Used under license from Shutterstock.com.

Apple keyboard. Courtesy Kelly Ulkak Moss.

Photo, Japanese capsule hotel. ©iStockphoto.com/lifehouseimage.

Photo, capsule hotel Asahi Plaza. © 2009 Peter Woodman.

Photo, modern interior of server room in datacenter. Copyright © Oleksly Mark. Used under license from Shutterstock.com.

Photo, electrical power grid. Courtesy of Lois Stark.

Photo, evolution of buildings. Source: Scientific American.

Photo, Sheik Zayed road, Dubai. Photo by Matt Makes, Turner Construction Company.

The Periodic Table as helix. From C.J. Monroe and W.D.Turner. "A New Periodic Table of Elements," *Journal of Chemical Education*, 3, 1959-65 1926.

Photo, F&F Tower Panama. © Mario R. Duran Ortiz.

CHAPTER 4

Photo, aerial view of the Stack Interchange. Copyright © Tim Roberts Photography. Used under license from Shutterstock.com.

Photo, human DNA structure of the cell. Copyright © vistudio. Used under license from Shutterstock.com.

Photo, fingerprint vector. Copyright © lestyan. Used under license from Shutterstock.com.

Photo, water vortex. Copyright © Stocksnapper. Used under license from Shutterstock.com.

Photo, Visualization of Hurricane Floyd from the NOAA GOES satellite. Source: NASA.

Photo, incredibly beautiful spiral galaxy somewhere in deep space. Copyright © Vadim Adovski. Used under license from Shutterstock.com.

Photo, Guggenheim Museum. Courtesy of Mantas Snaus.

Photo, interior of the Guggenheim Museum. Courtesy of Jesse Zryb.

Photo, Auroville Galaxy model. Courtesy of OutreachMedia Auroville photographer Dominique Darr.

Photo, School of Arts, Design and Media, Nanyang Technology University. Used by permission.

Photo, Walt Disney Concert Hall. Source: Carol M. Highsmith Archives/Library of Congress.

Photo, The Niteroi Contemporary Art Museum. © 2009 Rodrigo Soldon.

Photo, model of Helix Hotel. Courtesy of Leeser Architecture.

Photo, Miami parking garage. Courtesy of Zaha Hadid Architects.

Photo, Urban Forest proposed project, Chongqing, China. Courtesy of MAD Architects.

Photo, fortress of the Old City Baku. Copyright © Ramil Aliyev. Used under license from Shutterstock.com.

Photo, computer-generated front elevation perspective render of Heydar Aliyev Center. Courtesy of Zaha Hadid Architects.

Photo, Heydar Aliyev Centre – Interior. © Helen Binet. Used by permission.

Photo, African dancer. Courtesy of Lois Stark.

Photo, Paquita Ballet. Dancers: Madison Morris and Joshua Stayton, Artists of Houston Ballet II. Photo by Amitava Sarka, 2009. Used by permission.

Photo, Thai Breakdancers. © Sry85. Used under license from Shutterstock.com.

Photo, Tribal Council. © Soaring Flamingo Co. Ltd. Used by permission.

Photo, corporate hierarchy. Courtesy of Alamy Limited.

Photo, Samsung Boardroom illustration. Courtesy of Charley Kifer and James Furr, Gensler Architects.

Photo, mortar and pestle with medicinal neem leaves over white background. Copyright © Swapan Photograph. Used under license from Shutterstock.com.

Photo, Surgeon operating. Source: US Department of Defense.

Image, Silhouette of man in meditative pose with chakras overlayed on to him. © Shooarts. Used under license from Shutterstock.com.

Photo, DNA background. Copyright © Leigh Prather. Used under license from Shutterstock.com.

CHAPTER 5

Photo, Visualization of the database used by Twingl. Courtesy of Andy Wilkinson.

Photo, Close-up of a computer processor microchip between the fingers in hand. Copyright © Thitisan. Used under licensed from Shutterstock.com.

Photo, DARPA napkin drawing. Courtesy Alexander McKenzie.

Photo, internet map. Copyright © internet-map.net, Rusian Enikeev.

Photo, young Buddhist using laptop. © iStockphoto.com/hadynyah.

Photo, Exterior, "The Vessel," Hudson Yards, New York City, 2016. Courtesy Heatherwick Studios/Forbes Massie.

Photo, Interior, "The Vessel," Hudson Yards, New York City, 2016. Courtesy Heatherwick Studios/Forbes Massie.

Photo, Exterior, "Learning Hub," Nanyang Technological University, 2015. Courtesy Heatherwick Studios.

Photo, Exterior, "Learning Hub," Nanyang Technological University, 2015. Courtesy Heatherwick Studios.

Photos, UK Pavilion, Shanghai. © Daniele Mattioli, interior © Iwan Baan. Used by permission.

Photos, UK Pavilion in Milan. Courtesy of Mark Hadden.

Photos, Supertree grove in garden by the bay - Singapore. Copyright © lidian Neeleman. Used under licensed from Shutterstock.com.

Photos, six clusters, Large Data Visualizations. Courtesy Sung Cho.

Photo, map of interacting proteins. Courtesy H. Jeong, S.P. Mason, A.L. Barbasi and Z.N. Oltavai, "Lethality and centrality in protein networks," Nature 411 41(2001).

Four photos, colorized bacteria colonies. Courtesy of Professor Eshel Ben-Jacobs/Gittit Dar.

Barter Shells. Monetaria Moneta illustration. Image courtesy Index Testarum Conchyliorum (1742) of Niccolo Gualtieri.

Earnings graph. Image Courtesy of Kelly Ulkak Moss.

Photo, ebay logo. Courtesy of ebay.

Panel of Native American Newspaper Rock petroglyphs Utah. ©iStockphoto.com/milehightraveler.

Photo, Close up of business news. Copyright © Janaka Dharmasena. Used under licensed from Shutterstock.com.

Photo, Man holding phone on nature. Copyright © pikcha. Used under licensed from Shutterstock.com.

Photo, bushmen at a campfire in the African bush, Namibia. ©iStockphoto.com/SerengetiLion.

Photo, General Skobelev, 1883. Artist Nikolai Dmitriev-Orenburg-sky, Irkutsk Regional Art Museum. Courtesy Proktolog.

CHAPTER 6

Earthrise, image of earth as seen from Apollo 8. Source: NASA.

Photo, temple of Bel Palmyra. Courtesy of Lois Stark.

Photo, 4D dynamic visualization of data from global sensors. Courtesy of Rudolf B. Husar, Washington University.

Photo, astronaut in space. Source: NASA.

Photo, fern on black background. Used under license from Shutterstock.com.

Photo, broccoli florets: Backgrounds Textures Abstract Green Natural. © Sergey Skieznev. Used under licensed from Shutterstock.com.

Photo, Leno River Delta, USGS EROS Data Center Satellite-Landsat 7. Source: NASA.

Photo, LeafTexture. © SK Herb. Used under license from Shutterstock.com.

Photo, Hadhramaut Plateau, South Yemen. Courtesy of NASA.

Satellite image of Lake Carnegie in western Australia. Source: NASA.

Photo, West Nile Virus. Courtesy National Agricultural Library, US Department of Agriculture.

Photo, Bronchoscopy image. Copyright © Guzel Studio. Used under license from Shutterstock.com.

Photo, STS-112 Spacewalk. Source: NASA.

Photo, Hadron Collider. Courtesy of the International Space Station and the European Organization for Nuclear Research (CERN).

Photo, Cat's Eye Nebula. Courtesy J. Patrick Harrington and KJ Borkowski (University of Maryland) and NASA/ESA.

Photo, Houston Seismic Room. Courtesy of Schlumberger.

Photo, White Matter Fibers, Parietal areas. Courtesy of the Laboratory of Neuro Imaging and Martinos Center for Biomedical Imaging, Consortium of the Human Connections Project, www.humanconnectomeproject.org.

Photo, growth rates of trees in a Panamanian forest. Courtesy of Gregory Asner, Carnegie Airborne Observatory.

Photo, land and soils revealed by cao. Courtesy of Gregory Asner, Carnegie Airborne Observatory.

Photo, Invisible Scaffolding of space. Courtesy of Ralf Kaehler, Oliver Hahn, Tom Abel (KIPAC/SLAC).

Eyewire photo. Courtesy of Alex Norton for Eyewire.

Photo, torus vectors oblique. © RokerHRO.

Galactic Engine Model: Origin of Life. From *Neuroreality: A Scientific Religion to Restore Meaning*: Bruce Eldine Morton, Megalith Books, 2011. Courtesy of Bruce Eldine Morton.

Photo, torus shapes. Courtesy of thrivemovement.com.

Photo, computer simulation of the generation of the Earth's magnetic field. Courtesy of Gary A. Glatzmaier (University of California, Santa Cruz) and Paul H. Roberts (University of California, Los Angeles).

Photo, human magnetic field. Courtesy of the HeartMath Institute, www.heartmath.org.

Monroe & Turner's Spiral periodic table from "A New Periodic Table of the Elements," from *Journal of Chemical Education*, 3, 1058-65, 1926.

Image, periodic table as a torus. Courtesy of Rafael Poza.

Photo, Guangzhou Circle. © Jianhua Liang. Used under license from Dreamstime.com.

Photo, Florida Polytechnic University by Santiago Calatrava. © Alan Karchmer. Used by permission.

Photo, Sheraton Huzhou. Courtesy of Chris McLennan Photography Ltd. [if 6.36b is used: Courtesy Marriott International.]

Photo, an aerial image of the Government Communications Headquarters (GCHQ) in Cheltenham, Gloucester. Courtesy UK Ministry of Defence.

Photo, Yanomami communal house. © Dennison Berwick/Survival International. Used by permission.

Photo, Bayaka pygmies in Central Africa. © Olivier Blaise. Used by permission.

Photo, Ouroborus Carving. ©iStockphoto.com/theasis.

Photo, DNA strand.

Photo, School of Arts, Design and Media, Nanyang Technology University. Used by permission.

Gelede Mask, Nigeria. Source: Brooklyn Museum.

Photo, young Buddhist monk using laptop. ©iStockphoto.com/hadynyah.

Aerial view of Stonehenge. Copyright © 2010 Hans Elbers, Fotovlieger.nl.

Photo, Dogok Dong condominium complex, Seoul, South Korea. Courtesy of Emerson.

Photo, Sheik Zayed road, Dubai. Photo by Matt Makes, Turner Construction Company.

Photo, earth rising sun elements. Copyright © Vadim Sadovski. Used under license by Shutterstock.com.

Acknowledgments

Three people were integral to the completion of this book—Kelly Ulcak Moss, Holly Walrath, and Amy Hertz. Kelly's good spirit and dedication kept the project moving and kept the details bound through even the most difficult tracking of obscure images and complicated copyright processes. Her artistic talents, patience, and perception were integral to the book's development. When Kelly moved from Houston, Holly Walrath—a gifted poet, keen editor, and dogged researcher—joined the project. Her intelligence, organizational skills, and writing talents have overseen every concept and every comma. Amy Hertz's editorial wizardry brought the book to life. With humor and insight she induced me to write more personal stories and reflections. I would not have found my voice, nor my publisher, without her. These three brilliant women are the pillars of the book.

My writing group lived with this book as intensely as I have for over a decade. If there is a good idea, a good sentence, or a well-organized section, likely it came from someone at this small table. These talented writers with superb books of their own—Ann Weisgarber, Judithe Little, Julie Kemper, Bryan Jamison, Rachel Gillett—have kept me sane and sailing on. Past members of this group—Leah Lax, Pam Barton, and Anne Sloan—also forwarded the progress of this book with their savvy suggestions.

Many guardian angels have critiqued drafts, forwarded the manuscript to wider worlds, offered invitations to speak, and kept me afloat. Andrea White introduced me to editors, designers, the right people at the right moment. Susan Vaughan graciously read

countless versions and bolstered me year upon year. Barry and Anne Munitz in Los Angeles, Eli Evans in New York, Richmond Mayo-Smith in Boston, followed my ideas as they evolved from myths to mental maps. Rob McQuilken was agent for an earlier version and Elizabeth Kaplan later endeavored to find a publishing home for the book. Rue Judd helpfully guided early stages of the manuscript. Nora Shire diligently aided my research and organized miles of notes and books in the project's initial stages. Joseph Newland guided me through the publishing process. Judy Gardiner's dedicated writing process inspired me, and her insights strengthened me. Dr. Barry Morguelan's energetic support fueled me to continue during the doldrums until the right momentum took hold. Pat Beard read early versions and suggested that shape was the spine of my message. Rachelle Doody analyzed drafts in depth, despite her many other deadlines. Karen Lawrence's comments encouraged my path. Francine LeFrak, Ellen Flamm, and Mary Ralph Lowe sent early versions to publishing friends for guidance. Stephanie Cooper, Howard Weinberger, and Sara Gund opened doors of opportunity to spread my thoughts. Tahdi Blackstone created events to exchange ideas. Robert Wilson offered a chance to share these ideas with international artists at The Watermill Center.

It takes a village. The support and uplift from Carol Neuberger, Nancy Dunlap, Gail Gross, Ramona Davis, Surpik Angelini, Ann Friedman, Cyvia Wolff, Ellen Susman, Judy Allen, Kathryn Ketelsen, Nancy McGregor Manne, Josephine John, Sharon Lorenzo, Diane Bodman, Margaret Gardiner, Gloria Tenenbown, Maurie and Philip Cannon, and Ellen and David Epstein were there through highs and lows, dusting me off or celebrating. Esther Ochoa encouraged the book's progress as she expertly tended to the pieces of daily life. All of these individuals have been my safety net and launch pad.

Greenleaf Book Group was the birthing home of this book. Kat Fatland's careful eye and searing mind made edits that brought out hidden ideas and wove the narrative more gracefully. The team there—from Justin Branch's welcome, Tyler LeBleu's coordination, to designer Brian Phillips' openness to ideas—surpassed my best hopes.

My sister, Gail Farfel Adler, held out her hand to me all my life. Her support, candor, and sharing strengthens and sweetens my life. When what I wrote was confusing, she told me so. When she liked it, I could continue. As cheerleader and touchstone, she is always there.

This book is dedicated to my beloved family. My parents, Esther and Aaron Farfel, encouraged curiosity, imagination, ever-larger questions,

and were the epitome of living with an open mind and loving heart. Their vision, compassion, and innovative ideas endure in the world and remain my north star.

Our son Daniel inspires us still, with the courage, wisdom, sense of adventure, and sense of humor he embodied during his short, impactful 21 years.

Our son Ben has been my mainstay, reading draft after draft with his comprehensive mind and keen eye, pinpointing when it hit the essence and when it was off the mark. He always sees the big picture, knows where to focus, and guided each stage of the endeavor, no matter how full his own calendar. The clarity of his feedback and the constancy of his uplift were vital to the book and to me.

My husband George has been my ballast and buoy through the many years and byways of this book's making. As these ideas were gestating, he gave wise counsel at the right moments, encouraged my explorations, and endured years of my late-night writing. Without his support, patience, and understanding, I would have not made it to the finish line. My gratitude, my love.

About the Author

Lois Farfel Stark is an Emmy Award-winning producer, documentary filmmaker, and author. During her distinguished career she produced and wrote over forty documentaries on architecture, medical research, wilderness protection, artists, and social issues. With NBC News, she covered Abu Dhabi's catapult to the 20th century, the British withdrawal from the Persian Gulf, Cuba ten years after their revolution, the Israeli Air Force in the Six Day War, Northern Ireland during its time of religious conflict, and Liberia's social split.

Along with an Emmy, Lois is also the recipient of two CINE Gold awards, two Gold Awards from the International Film Festival of the Americas, the Matrix Award from Women In Communications, the American Bar Association Silver Gavel Award, and the Silver Award from the Texas Broadcasting Association.

In civic life she has served as trustee or director of Sarah Lawrence College, the Alley Theatre, Texas Children's Hospital, St. John's School, the Harry Ransom Center, Federal Reserve Board of Dallas Small Business Committee, Texas Commission on the Arts, Humanities Texas, the Joseph Campbell Foundation, and Harvard Kennedy School Women's Leadership Board. She was elected to the American Leadership Forum, the Center for Houston's Future, and the Philosophical Society of Texas.

She graduated Sarah Lawrence College and has two Master of Art degrees, in Education and Communication. She lives in Houston, Texas.

For more information, visit www.loisfstark.com.